# IMAGES
## *of America*

# EARLY ASPEN
# 1879–1930

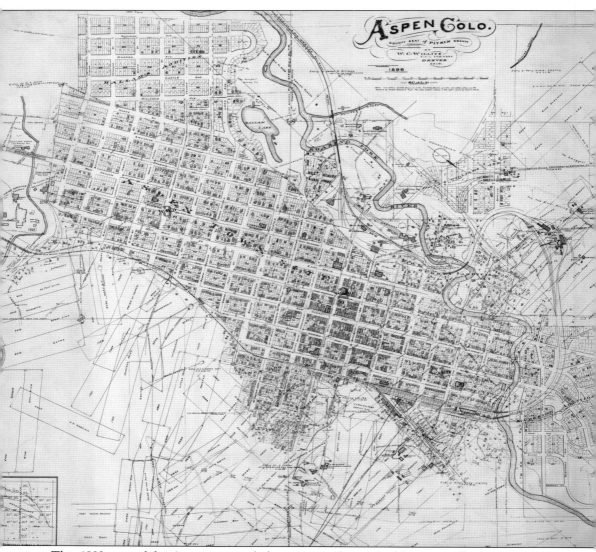

This 1893 map of the Aspen area includes streets and some buildings as well as mining claims overlaid in the town and surrounding mountains. The map provides a good view of where the competing railroads had their yards and depots. The Colorado Midland was on the south side of town with its station at the foot of Aspen Mountain. The Denver & Rio Grande was on the north side of town. (Courtesy of the Aspen Historical Society.)

ON THE COVER: Taken August 19, 1898, this image is from a five-by-seven-inch glass-plate negative of the Gentry Brothers Dog and Pony Show parading down Cooper Street between South Galena and South Hunter Streets. Off in the distance is West Aspen Mountain, later renamed Shadow Mountain. The Independence Building is on the left with a light that says "Furnished Rooms." The Tompkins Hardware store is across the street at the intersection of Cooper and Galena Streets. Even farther down the street on the right is Tom Latta's Brick Saloon, later known as the Red Onion Saloon. Note all the overhead wires, supplying direct current for both street lights and mines. Alternating current was provided for the businesses and residents. The wires may have also been for Western Union and telephone lines. (Courtesy of the Aspen Historical Society.)

IMAGES
*of America*

# EARLY ASPEN
# 1879–1930

Douglas N. Beck

ARCADIA
PUBLISHING

Published by Arcadia Publishing
Charleston, South Carolina

Printed in the United States of America

Library of Congress Control Number: 2015941076

For all general information, please contact Arcadia Publishing:
Telephone 843-853-2070
Fax 843-853-0044
E-mail sales@arcadiapublishing.com
For customer service and orders:
Toll-Free 1-888-313-2665

Visit us on the Internet at www.arcadiapublishing.com

*To my wife and best friend, Julie, for encouraging me every day and believing in me; my children, Hunter and Kira, for promising to read my books; and my father, Neil, and "Uncle" Paul for giving me a lifetime of memories and stories about Aspen.*

# CONTENTS

Acknowledgments                                                              6

Introduction                                                                 7

1.   A Growing Community                                                      9

2.   Notable People, Organized Labor, and Secret Societies                  17

3.   Businesses, Homes, and City Life                                       39

4.   Events, Disasters, Lawsuits, and Discoveries                           67

5.   Aspen Becomes a City                                                   77

6.   Social Organizations, Religions, and School Life                       89

7.   The Mines, Miners, Mills, and Railroads                                99

8.   Life in a Small Town at the End of a Boom                             121

Bibliography                                                               127

# ACKNOWLEDGMENTS

My appreciation goes to my wife and children for keeping me focused. Thank you to my extended family, especially my father, Neil Beck, and his first cousin, "Uncle" Paul Beck. They bring Aspen's history alive and give it meaning to the generations that have and will follow.

I want to thank Anna Scott and Megan Cerise from the Aspen Historical Society for helping me with hours of research, answering all my questions no matter how many I asked. They filled in many gaps and corrected some of my historical errors. Without them and the Aspen Historical Society (AHS), this book never could have happened. Thanks to Coi Drummond-Gehrig at the Denver Public Library Western History Collection (DPL) for providing a few hard-to-find images of some of Aspen's most prominent pioneers. Thanks to the History Colorado Research Library for giving me a quiet place to work and access to many of Colorado's historical newspapers.

I want to extend my appreciation to Mary McCarthy for providing such a valuable research tool as the Colorado Historic Newspapers Collection (www.coloradohistoricnewspapers.org). This collection of many of Colorado's newspapers in digital and searchable format is an invaluable tool for all Colorado history researchers and archivists.

Lastly, thanks to all of Aspen's early historians who have documented so much of Aspen's history. I thank them here as a group and provide individual acknowledgements in the bibliography. Unless otherwise noted, all images appear courtesy of the Aspen Historical Society.

# INTRODUCTION

In Aspen's early history, the region started out as a peaceful valley, home to a band of Colorado Ute Indians. Although first settled in 1879, perhaps Aspen's history could actually be traced back to 1873, when Ferdinand Vandeveer Hayden, following his earlier surveys of the Yellowstone area in Wyoming, focused his energy and resources on a number of expeditions in Colorado. With tacit permission from the Ute Indians, Hayden's teams documented many of the natural resources as well as plants and animals within Colorado. Some of his data was later used by geologists and miners.

On July 4, 1879, a group of four prospectors arrived in the Aspen valley, having crossed the Continental Divide from Leadville, Colorado. On their first night on the valley floor, the team encountered another team that had also come over from Leadville. There is some debate over which team arrived first; either way, they arrived on the same day and within hours of one another. Avoiding the local Indians, both teams set out to stake their claims on the valley floor as well as in the surrounding mountains. In all, both teams stayed in the valley for only a few days before returning to Leadville to officially register their many claims. Names for each claim were assigned; some of the named claims would later play into Aspen's mining glory and hard-fought legal battles. In 1879, the stage was set, and Aspen's destiny was now in the hands of entrepreneurs, miners, lawyers, and most importantly, federal regulators.

Despite the winter of 1879–1880 being one of the harshest on record, miners, entrepreneurs, prospectors, and businessmen poured into the new mining camp. Some brought their families, others brought their money, and even more brought dreams of riches. Originally conceived as Ute City, the name was eventually established as Aspen. It took little time for Aspen's biggest names to arrive in the valley, if not physically, then as investors in what would become some of Aspen's largest mining operations. They also brought the hope of high society, hotels, banks, and eventually, railroads.

Names such as Jerome B. Wheeler, David M. Hyman, H.P. Cowenhoven and family, Henry B. Gillespie, James J. Hagerman, B. Clark Wheeler (no relation to the other Wheeler), Walter Devereux, and David R.C. Brown became etched in Aspen's history—good and bad. These men, along with other pioneers, became both partners and adversaries with epic legal battles and outcomes that changed mining laws throughout the country. They were also responsible for giving Aspen a government, civic infrastructures, unionized miners, schools, churches, and social venues. They convinced Colorado's biggest railroads to race to the valley to be the first to serve the mines and locals alike. These men kept more than their fair share of lawyers busy.

With the enactment of the Sherman Silver Purchase Act of 1890, there was a guaranteed market for all the silver that could be extracted from the valley at a guaranteed price per ounce. In a few short years, Aspen had over 15,000 year-round residents. There were social clubs, secret societies, multiple unions, boxing and baseball clubs, brothels, saloons, and even its share of crimes, including some notable criminals of the day. The world-class grifter Soapy Smith spent

time in Aspen, as did the most famous lawman of his time, Wyatt Earp, who even owned a saloon in Aspen for a short time. People from all over the world came to Aspen.

Aspen was thriving through the 1880s and into the early 1890s, and the golden age lasted until the Sherman Silver Purchase Act was repealed in 1893. Pres. Grover Cleveland was no fan of silver and set out to abolish the guaranteed purchase of the precious metal by the US Treasury. With the stroke of a pen, Aspen's fortunes changed overnight. Mines ceased operations, businesses closed or were seized by creditors, and once-lavish homes were abandoned or torn down for firewood to heat the homes of those trying to stay on. Some of the wealthy investors did their best to keep their operations open, some by cutting wages and increasing working hours for the miners, others by selling more stock to unwitting investors and pouring the funds into their remaining producing mines. Eventually, all but a handful of mines shuttered. The town was nearly abandoned by the early 1900s. David M. Hyman made a few attempts to reopen some of his properties, but that was short lived. All of the big names abandoned Aspen, with the exception of the Brown family.

By the 1920s, Aspen and the surrounding valley had fewer than 800 residents, and even that number dropped considerably in the next few years. Although not completely abandoned, Aspen had entered its quiet years, waiting for demand for silver to return or something better to shape its future. Some of Aspen's most famous investors lost everything and died in obscurity. A few survived by moving to new frontiers and fortunes farther west or by returning to their roots back east.

Although there are many photographs and historical facts from Aspen's early days, the subject matter was often the people with all the money and not the year-round locals who eventually lived there for many generations, some of whom still live in the valley. This book has opened my eyes to the characters both good and bad who shaped Aspen's past and future. Names I grew up admiring turned out to often be on the wrong side of history, while others often relegated to mere footnotes were the real heroes. I hope this book inspires you to dig deeper into the history of Aspen and the people who kept it alive in spite of the economy, world affairs, and lost riches.

# One

# A GROWING COMMUNITY

From the arrival of the two original prospecting teams in the summer of 1879, Aspen was on a path of accelerated growth. Inside of its first year it had two names, two town development companies, and a number of claim jumpers. It saw the last of the Ute Indians heading north and an onslaught of prospectors coming from all the other directions.

Aspen already secured the attention of big-money investors from the East. Some never even visited the valley, but their money had a profound impact on the success and eventual decline of the community.

Getting to Aspen in the first few years was not an easy task. Although only a short distance as the crow flies from Leadville, the trip often took three or more days in harsh conditions. To make matters worse, the winter of 1879–1880 was one of the harshest on record. Aspen's summers were a few short months, and the rest of the year the ground froze harder than steel. Getting at Aspen's riches was not for the faint of heart.

In 1880, Aspen was officially incorporated as a town. Five years later, 72 percent of the population was male, and 99 percent of that was white, with the rest comprised of blacks, Indians, and biracial men. The population hit 3,800 residents by that time, including four prostitutes.

Politics were important in the new community, and few missed a chance to vote. Initially, only men could vote. Aspen local Davis Waite ran for governor on the Populist ticket and won largely on the topic of women's suffrage. Ironically, he was voted out of office by the newly empowered women of the state. Women also tried to maintain certain morality standards but lost out in part due to the single men who spent their off time in the saloons or enjoying outside activities such as boxing or baseball. Some also spent time with the ever-expanding population of prostitutes.

Aspen even had an employee on the payroll with the title of scavenger, whose job was to keep the streets, gutters, and vacant lots clean.

One of the three routes into the valley used by the early pioneers was over Independence Pass. The shortest but most treacherous route from Leadville, it also passed through the short-lived gold-mining camp of Independence. Within a few years, the route was improved and turned into a toll road.

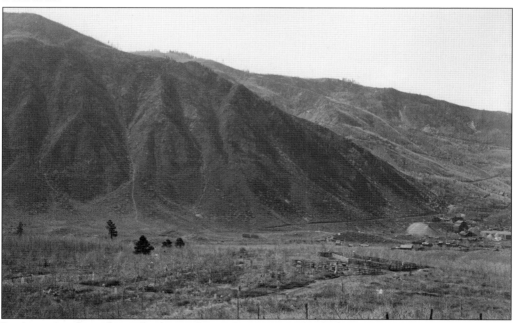

Looking west from above the Aspen Grove Cemetery on Smuggler Mountain, the mine dumps of the Durant Mine, Thousand and One Mine, or Argentum-Juniata Mine are visible, as well as the powder house and the flank of east Aspen Mountain. The cut across the lower part of the mountain is either the Colorado Midland railroad spur to the Veteran Tunnel or a mining road.

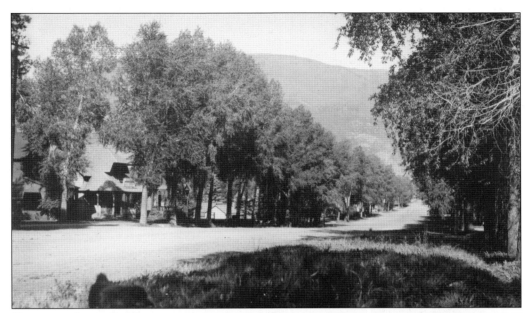

Cottonwood trees lined the streets and sidewalks of Aspen in its early days. Although most of the trees in the surrounding hills and valleys were cut for lumber to support the growing community and mines, trees lining the streets were either left to grow or even supplemented by additional cottonwoods. Many of these trees were still lining Aspen's streets well into the 20th century, and some still exist today. The earliest photographs of Aspen show very few of the trees, but local clubs, churches, and arborists planted as many as they could once the streets and sidewalks were platted. These two photographs were taken in the 1920s.

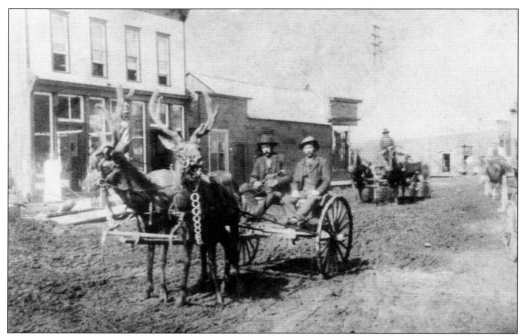

Two local men are pictured here in a carriage being pulled by elk around 1880. It is unknown if the elk were used as a novelty or out of necessity. The driver is identified as Orren Fairbank from Michigan, but the passenger's identity is unknown.

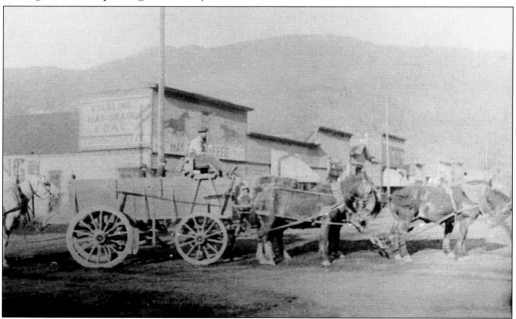

An ore wagon pulled by a team of four horses is stopped on the corner of Cooper Avenue and Hunter Street. In the early years, everything brought into the Roaring Fork Valley came by wagons or on the backs of pack mules or donkeys. Sometimes it took entire jack trains to bring enough supplies to meet certain needs or during winter months when passage was difficult.

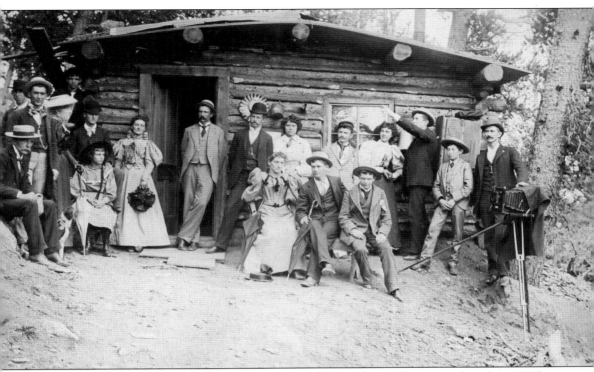

This is a family or group photograph in front of a mountain cabin in the trees, taken about 1895. In the early days, life was hard, and living quarters were limited. Even then, everyone had their Sunday finest clothes to wear and often wore them for everyday life, only donning work clothes when on the job. This photograph appears to be staged for a special occasion. Note the second camera off to the right.

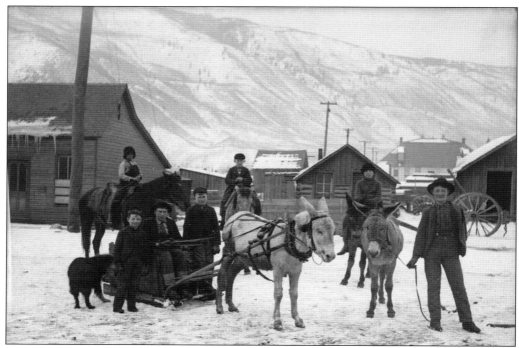

Around 1889, seven unidentified local boys play with a sleigh and donkeys. The Garfield School can be seen behind several other buildings, and Red Mountain is behind them. Even in Aspen's earliest years, the children found plenty to do with their spare time, spent mostly outdoors.

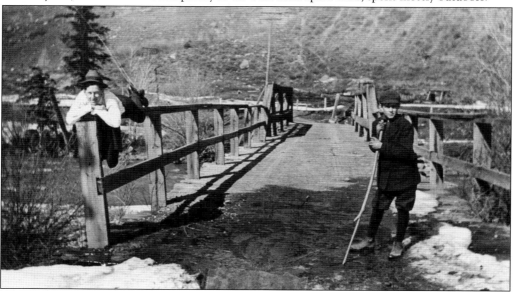

The Slaughterhouse Bridge was used for crossing the Roaring Fork River in the valley northwest of town, down Snowbunny Lane. The man is identified as Mr. Beckner, a teacher in the Aspen School who eventually became the principal of the Washington School. The boy is Irving Adams, an accomplished basketball player during his school years. The road and bridge were a back way in and out of town.

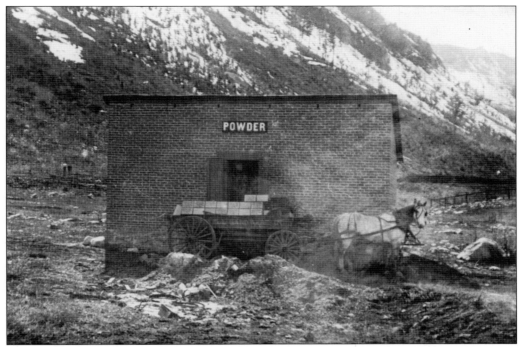

This small brick building was the powder magazine belonging to L.H. Tomkins Hardware Company, and it was located east of Aspen beyond the Ute Cemetery. For safety reasons, the town fathers required all explosives to be stored outside the city limits.

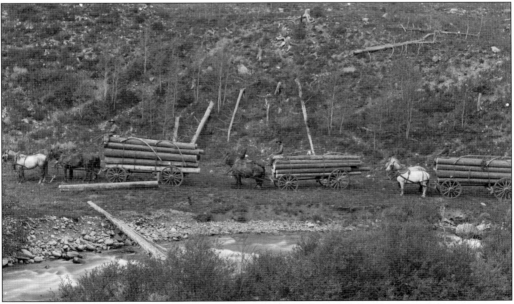

Pictured here are three teams of horses pulling wagons filled with lumber. Lumber was a major industry in all of the mining camps; not only was it used for building homes and businesses but also in the mines to shore up the tunnels or in the support structures. At one time in the 1880s and 1890s, Aspen had over a dozen local sawmills.

Aspen's rapid growth not only as a mining industry but also as a community is evidenced in this photograph by the number of homes and businesses built in its earliest of years. As soon as the town development company plotted out the roads and started selling off the lots, a building boom took place. The earliest buildings were built with rough-cut lumber. With sawmills opening up all over the valley, finely cut lumber became easier to get, although people building homes had to compete with the building of the mines. Some of Aspen's earliest buildings still exist today, nearly 150 years later. In this photograph, the massive harvesting of trees for lumber had not yet occurred on the immediate slopes around town. This would soon change as demand for more lumber exceeded available supplies farther down valley. Eventually, lumber would need to be shipped in by railcar from out West.

# Two

# Notable People, Organized Labor, and Secret Societies

Aspen was home or a stopover for some notable people in its early years. Denver's most famous grifter, Soapy Sales, paid Aspen a number of visits. With a penchant for violent outbursts, many tolerated his existence rather than take him on. He ultimately ended up in Alaska, where he met his untimely death.

David Hanson Waite settled in Aspen in 1881. He launched the *Aspen Union Era*, a weekly newspaper that championed reformist ideals, unions, and the Populist Party. In 1892, Waite was elected governor on the Populist ticket. He was a member of one of the miners' unions also regarded as a secret society that anyone could join, the Knights of Labor. Horace and Baby Doe Tabor built a house in the Ashcroft area and spent time there escaping the social requirements of Leadville.

Aspen was home for a short time to Wyatt Earp and Josephine "Josie" Marcus. They arrived via stage on May 5, 1885, and stayed through late November. While in Aspen, Earp became a partner in the Fashion Saloon on Cooper Street between Galena and Mill Streets. While in town, he was asked by US Marshal E.M. Mills to help arrest James Crowthers, who was wanted in Arizona for a Wells Fargo stage robbery.

Aspen's most notable were the mine owners and entrepreneurs in the valley. Some owned all or part of Aspen's biggest mining operations. Others ran companies that processed the ore. Also among them were the owners of Aspen's banks, hotels, and saloons. In later years, the railroad tycoons became part of Aspen's fabric. Names such as Jerome B. Wheeler, David M. Hyman, Henry P. Cowenhoven, David R.C. Brown Sr., B. Clark Wheeler, Henry B. Gillespie, James J. Hagerman, and Charles A. Hallam were among the biggest mine and land owners. Walter B. Deveroux, Byron E. Shear, Joseph "Diamond Joe" Reynolds, David H. Moffett, Aaron M. Deming, Alfred Lamb, and John Bowman played key roles in the community, supporting the mines, miners, locals, and visitors alike.

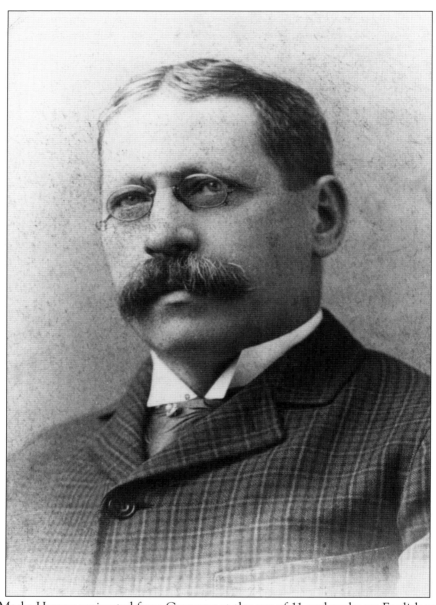

David Marks Hyman emigrated from Germany at the age of 11 and spoke no English upon his arrival in 1857. He attended Harvard Law School and graduated in 1870. Through business dealings in his adopted city of Cincinnati, Ohio, Hyman came to know another Aspen pioneer by the name of Charles A. Hallam. In 1879, Hallam proposed that the two move to Colorado to seek a fortune in the mining industry. Hyman's first mining venture was to invest $5,000 in Hallam's Colorado mining ambition. Hallam, in turn, invested his money as well as Hyman's into a venture headed up by B. Clarke Wheeler. On January 22, 1880, Hyman became an investor in seven and a half mining properties along with Hallam and Wheeler. Many of these mines would play an important role in Aspen's history in just a few short years. Hyman's interests also included half of the Steel Mining claim. These claims were all purchased for $165,000, most of which came from investors back in Ohio willing to trust Hyman with their money.

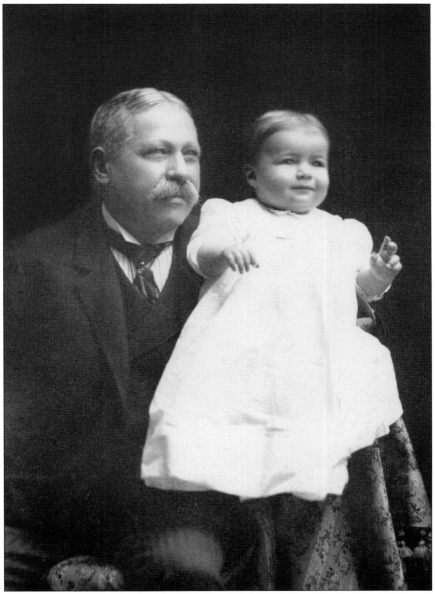

David Hyman is pictured here with his grandson Alfred Friedlander Jr. Over the following years, Hyman was involved in a number of mining operations. He was also part of some of the biggest legal battles involving mines and labor issues in the country. Along with Wheeler and Hallam, the three men laid out the town, including all the streets, blocks, and lots. Hyman never actually lived in Aspen but did have a home there that he and his family occupied when in the valley. In 1899, after the silver boom ended, Hyman moved on to New York City and then Idaho, working for the Guggenheim brothers' American Smelting & Refining Company. He returned to Aspen in 1908 and attempted to revive his Aspen properties. The Della S and Smuggler jointly dug a 1,200-foot shaft called the Free Silver shaft. It failed to produce any ore. Water was allowed to fill up to the ninth level, each level separated vertically by 100 feet. In 1917, Hyman ended his relationship with Aspen and never returned to the valley again.

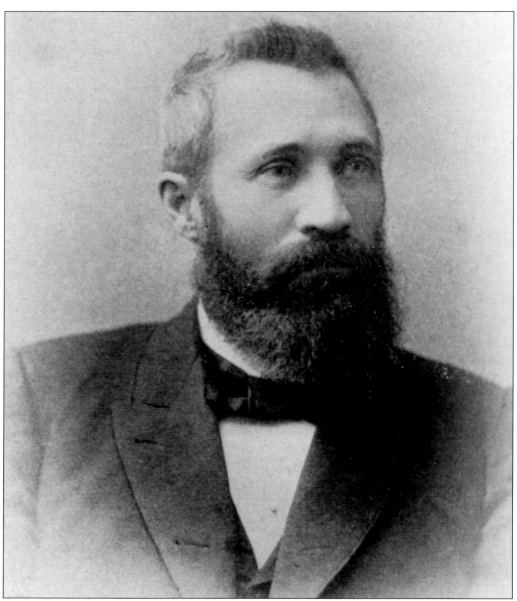

Byron Clark Wheeler, better known as B. Clark Wheeler, was an accomplished self-promoter, geologist, professor, state senator, and businessman. Wheeler owned a number of mines over the years and was the owner and publisher of the *Aspen Times*. While another forefather of Aspen, H.B. Gillespie, was in Washington trying to establish Ute City through support of the US Postal Service, Wheeler claimed Aspen as his, and along with his partners immediately established the Aspen Town and Land Company, incorporating Aspen in the summer of 1880. Originally from Philadelphia, Pennsylvania, he took Horace Greeley's advice and headed West. During his travels, he met up with Charles A. Hallam and formed a partnership that would last for years. Hallam, originally from Cincinnati, knew David Hyman and felt the three of them could strike it rich in Aspen. He died in Los Angeles, California, in June 1914. Many believe Aspen never would have become Aspen had it not been for B. Clark Wheeler. (Courtesy of the Denver Public Library)

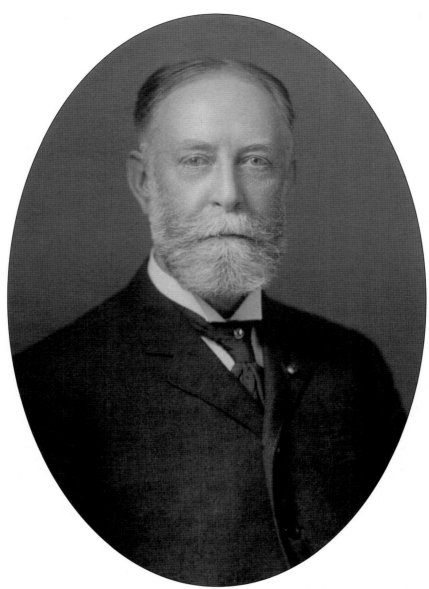

Jerome B. Wheeler was the second, but more significant, of the Wheelers to come to Aspen during its early days. Many of Aspen's most prominent landmarks were built by him, most notably the Hotel Jerome and the Wheeler Opera House. Jerome B. Wheeler came to Aspen from New York City, where he was a minority partner in R.H. Macy & Company. He even eventually sold his interest in the Macy's department store to other family members. One of his earliest investments was in the lixiviation works, completing what others had failed to do, as the first investors had gone bankrupt before the plant was completed. Wheeler also purchased or invested in numerous mines in the valley and was party to the largest lawsuit in mining history. Due to his enormous wealth, lawyers and miners alike filed lawsuits against him claiming fraud and deception in his business dealings. Wheeler also invested in the future railroads coming to Aspen, with a major stake in the Colorado Midland Railroad with his longtime friend and associate John James Hagerman. He also owned a bank, numerous buildings, and considerable real estate throughout the valley.

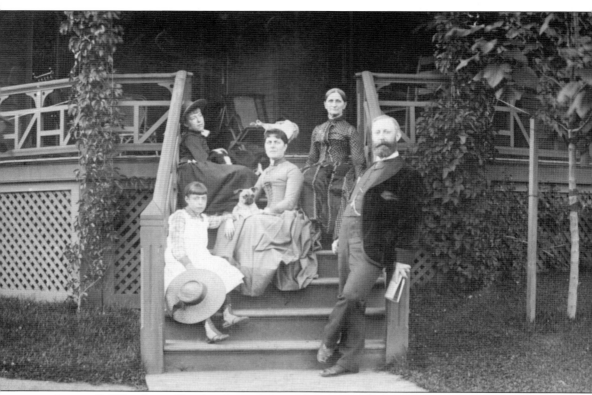

Jerome B. Wheeler and his family are pictured here at their home in Manitou Springs, Colorado. The three women on the stairs are, from left to right, Elsie Wheeler (Rupp), Charlotte Macy Valentine, and Harriet Macy Valentine (Wheeler). Marion Wheeler (Cable) is the girl in the white dress, and Jerome B. Wheeler is standing at right. Wheeler was known to be an honest businessman and either settled out of court or won all but a few suits leveled against him. After the silver boom ended and Aspen went into decline, Wheeler moved his family to Manitou Springs, Colorado, where he lived out his days. The Colorado Midland Railroad, based in Manitou Springs, eventually failed and went into receivership, Wheeler lost everything, and he died penniless. A number of Aspen landmarks still bear his name.

Henry Bramblett "H.B" Gillespie was the first person to try to incorporate the Roaring Fork Valley into a city. While in Washington, DC, to get Ute City recognized by the US Postal Service, B. Clark Wheeler came into the valley with his group of investors and platted the entire valley through the Aspen Town and Land Company. Upon Gillespie's return, he saw that his plans had been superseded. Instead of fighting it, he joined forces with Wheeler. Gillespie became the principal owner of the world-famous Mollie Gibson Mine and sold it at just the wrong time. He held interests in other significant mines over time, including Spar Consolidated. Most of his mines were sold off to Jerome B. Wheeler, putting an end to numerous lawsuits. Gillespie invested in the Jones Hand Drill manufacturing company, which manufactured a tool that revolutionized mining of the day. Col. H.B. Gillespie made and lost numerous fortunes before retiring from active business in the early 1900s. He died while traveling in Africa on April 20, 1903.

Aaron M. Deming (1822–1893) was the proprietor of the second Clarendon Hotel around 1885. After the first Clarendon Hotel burned down in 1884, the new Clarendon Hotel was constructed bigger and better than the first. At some point not long after the reconstruction, Deming became the owner of what was one of Aspen's best hotels, serving some of Aspen's most distinguished guests. He also ran the Clarendon Livery and Boarding Stables out of the back of the hotel. Deming was active in local charities as well as politics and helped Aspen to remain civilized. He died in 1893, and new management took control of the property, proclaiming it Aspen's best second-class hotel.

John James Hagerman came to Colorado in 1884 by way of Menominee, Michigan, where he made his first fortune. He initially moved to Colorado Springs and immersed himself in the industries of Colorado. One of his boldest investments was in the Colorado Midland Railroad. Between 1886 and 1887, the railroad made it across the Continental Divide to Aspen. In 1889, Gillespie invested in a number of Aspen ventures that produced significant wealth over the years. Although he never made Aspen his home, he did have a house built that he and his family would use during visits. Over the years, he invested in mines, mills, banks, and other non-mining ventures. He continued to own portions of the Colorado Midland Railroad until its financial demise. After the repeal of the Sherman Silver Purchase Act, silver prices plummeted to where it was not cost effective to mine, and investors lost millions. Hagerman was one of the few pioneers of Aspen to survive with some of his fortune still intact. (Courtesy of the Denver Public Library)

Henry "H.P." Cowenhoven and his wife, Margaret, and daughter Katherine "Kate" came to Aspen from Black Hawk, Colorado. The Cowenhovens, along with David Robinson Crocker "DRC" Brown, had decided to move to Arizona, and along the way they encountered a man camping at Twin Lakes, Colorado, who had just come from the Roaring Fork Valley. After hearing of the potential riches, they changed their plans and moved to Aspen the next day. Over the years, Brown continued to work for the Cowenhovens and even married into the family after courting Kate for many years. Cowenhoven and Brown became business partners in a store as well as ventures in mining, water, power, and banking. They did not arrive in Aspen wealthy but over time controlled many of Aspen's businesses. Cowenhoven died in June 1896 and Margaret died a year later, leaving their fortune to DRC and Kate. Kate died in 1898. H.P. Cowenhoven was known as a tough businessman willing to fight for what he believed, often putting him at odds with other Aspen benefactors such as Hyman, B.C. Wheeler, and Gillespie.

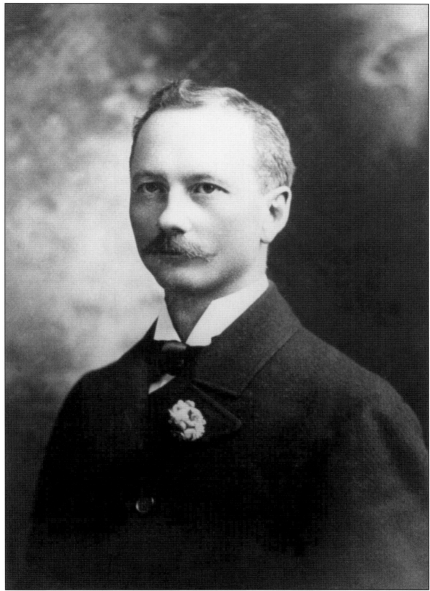

Pictured here in 1896, David Robinson Crocker "DRC" Brown was born in New Castle, New Brunswick, Canada, in 1856. He moved to Black Hawk, Colorado, in 1877 and went to work as a clerk in H.P. Cowenhoven's store. While working there, he started courting Cowenhoven's daughter Kate. In 1880, Cowenhoven decided to sell the business and seek a better life, possibly in Arizona. The Cowenhovens and Brown set out over the continental divide, stopping along the way to collect some debts in Como, Colorado. A few days later, near Twin Lakes they encountered a man by the name of Bill Blodgett, who had just come from Aspen. Convincing them that Indians were still on the rampage in Arizona and New Mexico, Blodgett told them of the fortunes to be had in Aspen. Cowenhoven immediately set out to build a building for their new store with land purchased from Blodgett. DRC eventually married Kate, making him a full partner in the Cowenhovens' growing empire. DRC and Kate had two daughters, Margaret and Henrietta.

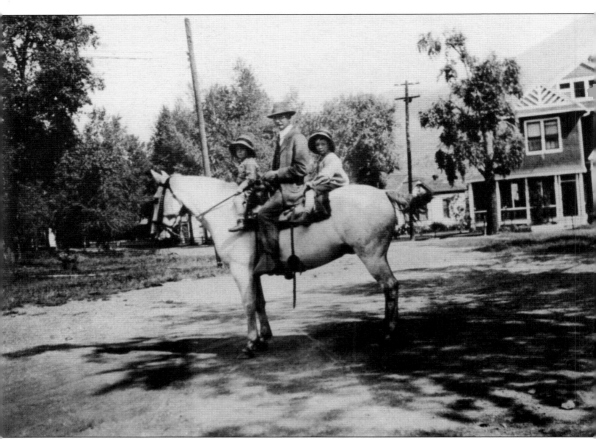

From left to right, Fletcher Brown, David R.C. Brown, and DRC "Darcy" Brown Jr. pose on horseback with William Judge Shaw's house at 206 Lake Avenue in the background, around 1918. DRC Sr. was an active outdoorsman, and instilled his love of the outdoors in his children. The Browns spent their summers hunting, fishing, camping, and going on days-long horseback riding trips into the backcountry. DRC enjoyed bringing his friends and family along on all his journeys. There are many photographs of DRC and his friends displaying the trophies of their successful hunting and fishing trips.

David and Ruth McNutt Brown, Brown's second
wife, are pictured here around 1910. After Kate's
death, DRC married Ruth McNutt in 1907. Even
though they spent most of their time in Denver,
they summered in Aspen. DRC continued to
run the businesses he and the Cowenhovens had
started while taking on the role of Aspen's premier
benefactor even after the silver boom ended. Ruth
and David had four children together, David
R.C. Jr., Fletcher, Gordon, and Ruth (Perry).

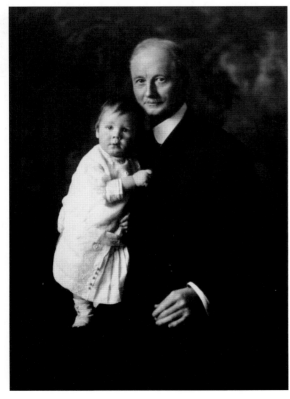

DRC Brown Sr. is pictured here
holding DRC Brown Jr. The Brown
family continued to influence
Aspen for many decades, including
turning their mining claims on
Aspen Mountain into what would
become the Aspen Skiing Company.
David R.C. Brown owned a ranch in
Carbondale as well as Hallam Lake.
He died in July 1930, leaving behind
an estate valued at over $1.5 million.

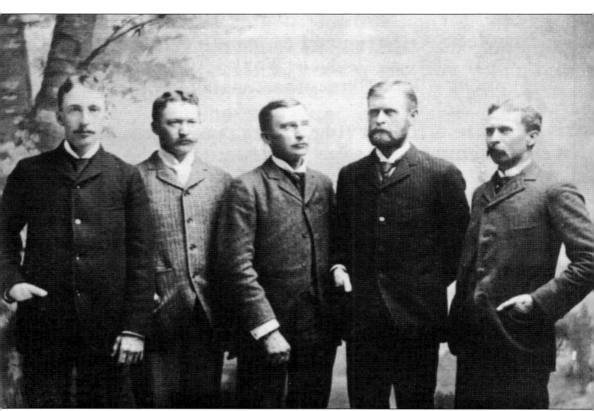

Pictured here are the Devereux brothers, from left to right, Paul, Horace K., James Henry, Walter B., and Alvin Jr. The brothers played key roles in Aspen's mining and milling operations. James Henry was married to DRC Brown Sr.'s sister Mary. Walter, the oldest brother, led the way to Aspen from New York after being hired by Jerome B. Wheeler to take over the smelting operations, which Wheeler was building out after other investors had failed to complete the plant. From 1883 to 1893, Walter was actively engaged in numerous mining and milling operations. Two of the brothers, James H. and Horace, followed Walter to Aspen and at times worked for their older brother. Walter invented and patented several devices used to improve the smelting process. On one occasion, Walter was stranded by a storm just outside of Aspen at a stage stop the day before Christmas. With no available snowshoes, he took wood casks apart, fastened staves to his feet, and set out for Aspen. He may have been the first skier in the valley, but this is not known for certain.

Marx Kobey, a local businessman and Mason, is pictured here dressed in a suit and top hat as master of the Masonic lodge. He was also a member of the Aspen Elks lodge. He owned the Kobey Shoe and Clothing Company, later renamed Kobey's, which specialized in men's clothing.

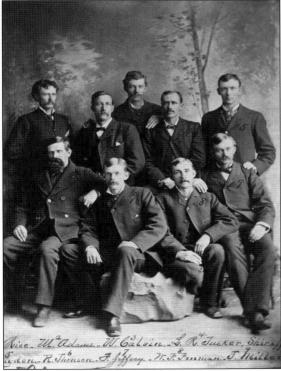

Nine men are posing here for a studio portrait. Included are M. Adams, W. Calvin, L.R. Tucker, R. Johnson, F. Jeffrey, W.R. Freeman, and J. Miller. Studio portraits of this type were once common and often involved families, church organizations, fire crews, and even miner's shifts. Most people wore their finest clothes every day, not only for photographs.

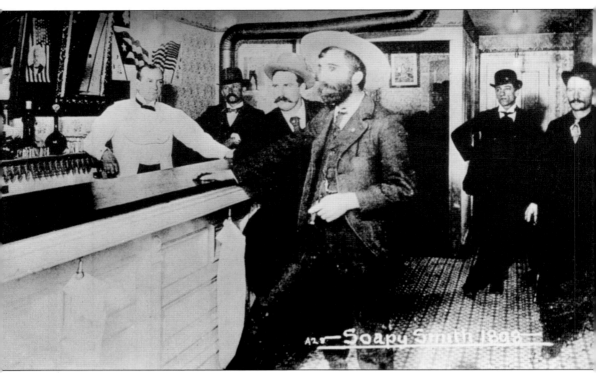

Jefferson Randolph "Soapy" Smith II was a famous con artist, two-bit gangster, and organized-crime boss of the Old West. His most famous scam was the prize soap racket, in which he hid a gold coin inside a bar of soap and convinced the crowd to buy up all of his soap in hopes of buying the one with the gold. The winning buyer in the crowd would always be one of his own men in on the racket. This scam is the source of the moniker "Soapy." Although active all over the West in the late 1800s, he is most famous for his activities in organized crime operations in Denver and Creede, Colorado, and Skagway, Alaska. In Denver, he ran several businesses that specialized in cheating their clientele. Denver is also where he excelled at political fixing, where he would sway the outcome of local elections. He used the same methods in Creede and Skagway, opening businesses with the primary goal of robbing his customers. Soapy died in a shootout on Juneau Wharf in Skagway on July 8, 1898.

Neither a colonel nor doctor was this fascinating man, but somehow John L. Bowman Sr. attained both titles, either vicariously or in error. Bowman was a wheeler and dealer, saloon man, photographer, and local character extraordinaire. He knew everyone's business, held court in his "Saloon and Musee" and looked after anyone needing help. He was famous and infamous alike in the local papers of his time. He was fined for breaking local laws while at the same time held in high regard by the police and town officials alike. Bowman's Saloon and Musee, constructed in 1893 in the Bowman Block, was an eclectic establishment to say the least. It had rare and unusual items for sale with even more items on display with a bar and pool table in the middle. There are a number of photographs of him drinking with friends and acquaintances in the back of the building and even behind it. Originally from Perryville, Pennsylvania, Bowman moved to Aspen in 1888, and lived there until his death on May 13, 1924.

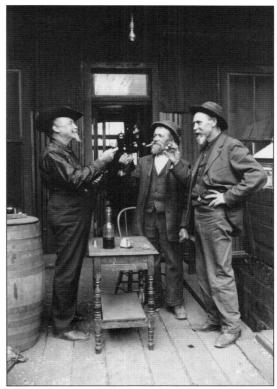

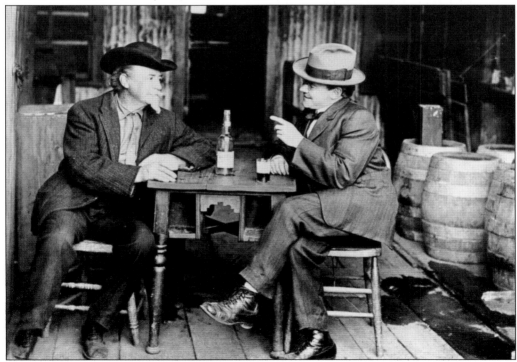

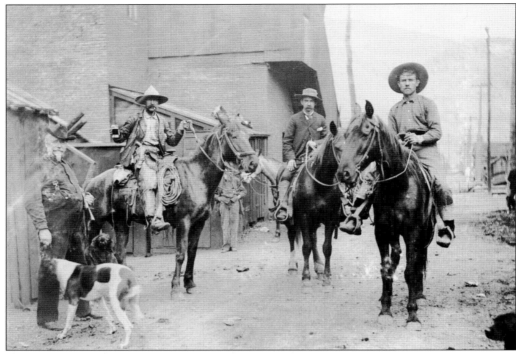

This photograph was taken in the alley behind the Bowman Musee and Saloon. The saloon was owned by "Colonel" John Bowman, who is standing at far left. In addition to Bowman, three other unidentified men on horseback are pictured, one holding a stein of beer.

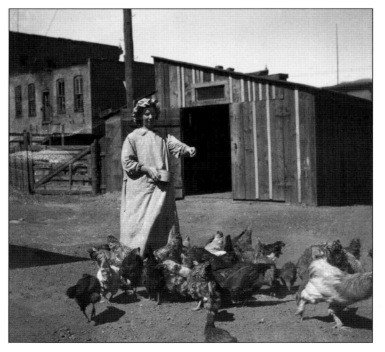

Mary Bowman is pictured here feeding chickens in the alley behind the Bowman Block (between Cooper and Durant Avenues and Hunter and Galena Streets). Part of the Independence Building and the Elks building flagpole are visible in the background. Mary was a bit of a cantankerous one, often ending up in court over disputes with her neighbors on any number of trivial items.

Ralph Crock is pictured here enjoying a glass of beer at Bowman's Saloon and Musee before and after having too many. There is a piece of paper on his arm that reads, "Send me home." Ralph Crock moved to Aspen in 1902, and brought his wife, Mary, and youngest son, Richard, over from Italy in 1905. The rest of his children arrived over the next few years. First to arrive was Frank in 1907, then Stanley in 1909, and lastly, Rosena in 1917. These dates are according to census records from that time. Ralph Crock worked at the Smuggler Mine for 10 years. Then, records show that he worked at the Hunter Mill for three years. According to the census of 1920, he listed his occupation as crusher man. Crock worked steadily until 1927, and he and his family lived in a home at 122 West Hopkins Avenue.

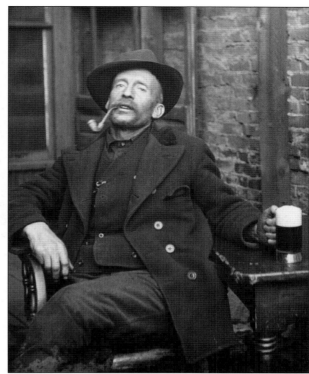

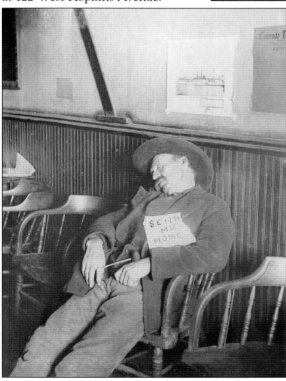

In the summer of 1885, Henry Gillespie and Henry Weber ordered Aspen's first pianos. Each was shipped at a cost of $1,000. They came by train to Leadville are were disassembled and ferried to Aspen by way of jack trains. Upon arrival, they were reassembled and delivered to Gillespie and Weber. Shipping was the biggest cost in obtaining the instruments. The children next to the piano are believed to be those of Henry Weber.

William G. Tagert owned W.G. Tagert Livery and Boarding Company in Aspen. He managed a large portion of freight that came into Aspen by jack trains or individual wagons. Tagert was also involved in improving the Independence Pass toll road as a safe route into the valley. The Tagert family has lived in the valley for generations; pictured here are Tagert's two daughters Nellie (left) and Wilma.

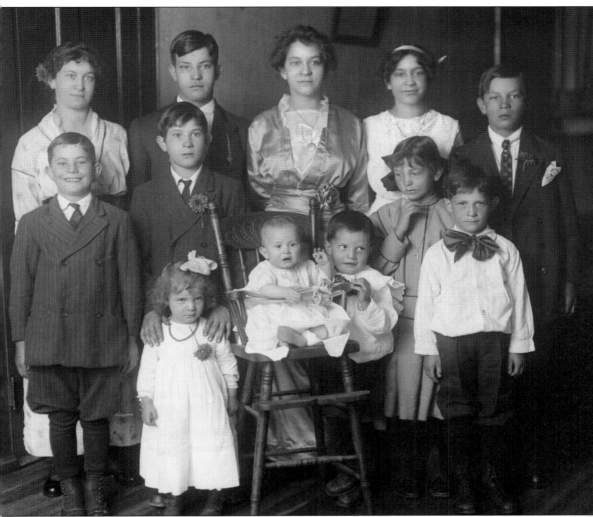

Pictured here around 1915 are the Marolt children. From left to right are (first row) Rosaline, baby Theodore (1914–1978), Michael (1907–1967), and Stephen; (second row) Louis (1904–1918), William (1902–1967), and Dorothea; (third row) Pauline (1896–1918), Frank (1897–1940), Mary (1894–1918), Elcia, and Rudolph (1900–1936). Mary, Pauline (married to John Ambrose, child Julia), and Louis died in the influenza epidemic of 1918. Another child, George, is listed in the 1910 census record, but he does not appear in the 1920 census. The 1910 census does not list Dorothea either, who then does appear in the 1920 census; she was most likely overlooked. In their early years, the Marolt families were farmers and ranchers, and much like many of Aspen's residents at that time, they dabbled in mining ventures and other local businesses. Most of the children pictured here lived out their years in the Aspen valley and raised families of their own.

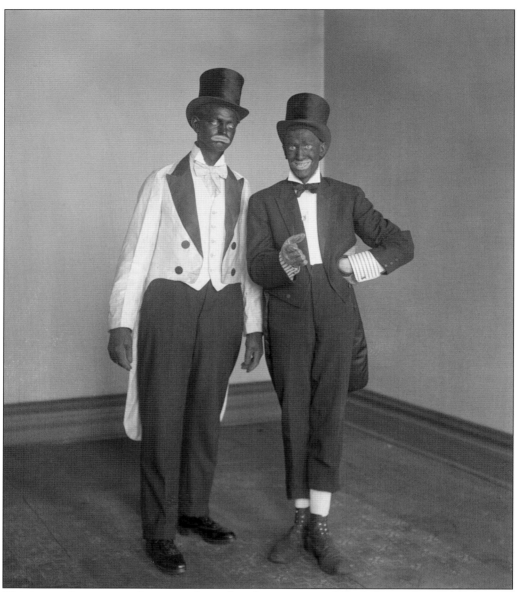

This is a studio portrait of two men dressed in the costume and black-face makeup for a minstrel show. Pictured are Happy Hogart (left) and Tom Flynn. Flynn was an actor, businessman, and local character. Beginning in the 1920s, he and his business partner Ted Ryan wanted to build a ski area on Mount Hayden. They started out by building the Highlands Bavarian Lodge up Castle Creek. They convinced André Roch to come to Aspen to design the ski area. Their plans were abruptly ended when Flynn signed up to fly for the British at the beginning of what would become World War II. Sadly, he was the first American aviator killed in World War II when he was shot down by the Germans.

# *Three*

# BUSINESSES, HOMES, AND CITY LIFE

It did not take long for Aspen to build a thriving business district complete with grocery stores, hardware purveyors, liveries, hotels, opera houses, banks, law offices, and sawmills. Churches and schools were some of the first structures built to support the growing population. Aspen experienced extreme growth in a very small amount of time and with it, jobs for anyone willing to put in an honest day's work.

Many of the earliest structures were constructed from rough-cut logs. As more tradesmen arrived, more permanent structures of lumber, stone, brick, and mortar were built. Mansions were erected of the finest quality to provide living space worthy of Aspen's elite. Row houses, cabins, and flop houses were constructed closer to the mines. The middle class built their homes close to Aspen's downtown area, and the mines served as the perimeter of town. As construction proceeded at a feverish pace, Aspen began to have a city feel, with all the hustle and bustle of any respectable community.

With the exception of the Wheeler Opera House, most sidewalks were constructed of wooden slats. They were easy to repair and even easier to keep clear of snow and ice in the winter. The Wheeler Opera House benefited from stone sidewalks made of the same sandstone material as the building.

Saloons were located mainly along Cooper Street. Hardware and mercantile stores as well as other businesses were spread throughout the core business area with one exception—the city fathers required all explosives be stored in buildings outside of town. Train stations were located on the north and south sides of town. Power plants and water facilities were by rivers and streams. The mills were by the mines, and the lixiviation plant was on the west side of town. Sports facilities were located on the flats northwest of town.

Summer activities included fishing and swimming on Hallam Lake, baseball games on the ball fields, and horse and bicycle races. Summers also included afternoon teas, cotillions, dances, debutant balls, and concerts under the stars. Picnics, rodeos, and camping were common activities for everyone.

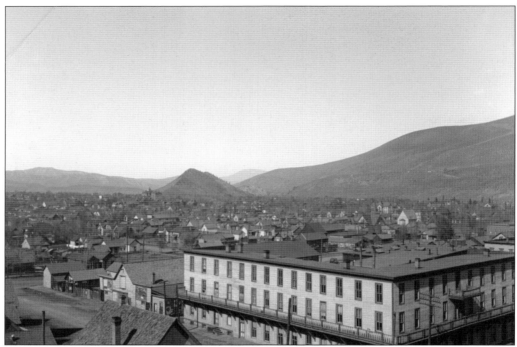

This view of Aspen in the early 1890s is looking west. The photograph was taken from the bell tower, and the Clarendon Hotel can be seen across the street. Red Butte is visible in the distance.

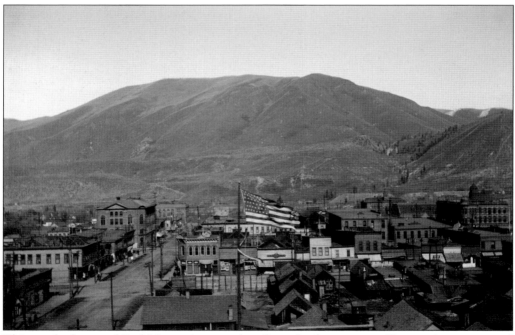

This overlook toward Red Mountain was taken from the fire tower on Durant Avenue around 1908; note that there are only 46 stars on the flag. Looking north down Mill Street, the Elks/Webber building, Wheeler Opera House, and Hotel Jerome are visible landmarks.

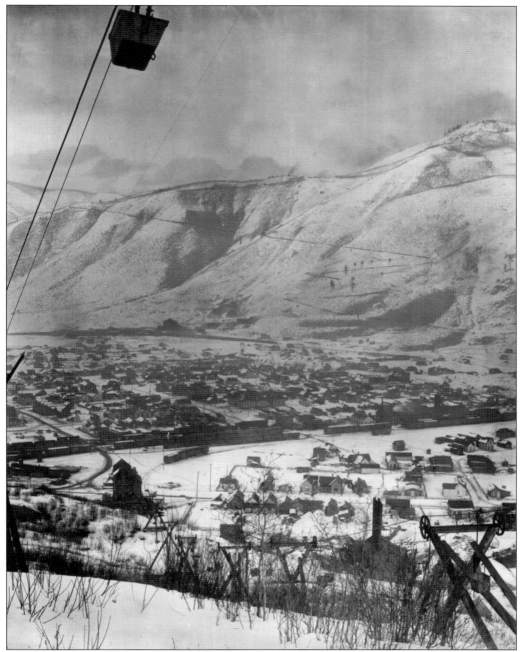

In this image of east Aspen from Aspen Mountain, the Durant Mine Company tram is in the upper left, and the Aspen Mine Company tram towers and ore house (smaller tram, lower right) are also visible, as well as the Argentum-Juniata Mine (smoke stacks, lower right). The Garfield School, the Colorado Midland Railroad trains and tracks, the east side of Aspen residential area, Smuggler Mountain and road, as well as Smuggler Mine and the Mollie Gibson Mine can also be seen. There is a light dusting of snow on the ground. The bottom of the image has the signature of William Henry Jackson.

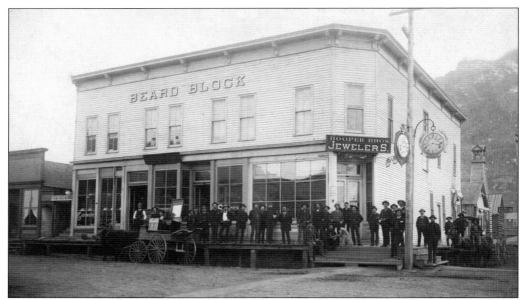

Pictured here is the Beard Block, on the corner of Mill Street and Cooper Avenue. There are people lining the boardwalk and wagons parked along the street. The most prominent sign is for Hooper Bros. Jewelers, and other signs along the building advertise furniture, glassware, and furnished rooms. The fire tower is visible in the background on the right. The Beard Block is in the 1890 city directories, but it does not appear in the 1892 directory, so it may have burned down.

This group of men is standing in front of the Berg Confectionery at 419 East Hyman Avenue. The man at far left is identified as Julius Berg. The photograph was taken before 1890, as the Cowenhoven & Brown building on the left was not yet standing at that time. Elizabeth Berg became the local selective service officer, a position she held for many years.

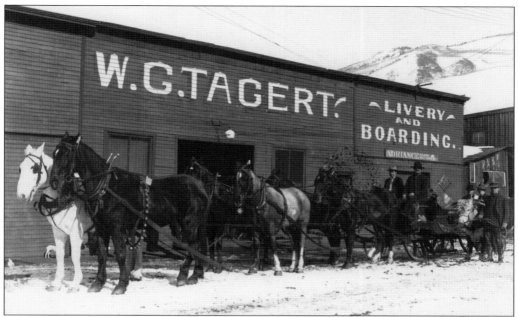

The W.G. Tagert livery barn is pictured here with a team of six horses hitched to a sleigh out front. Two unidentified men are in the front of the sleigh, with three more behind them with a man leading a bull. The sleigh is decorated with American flags, most likely ready for one of Aspen's many parades. W.G. Tagert lived well into his 90s and remained active to the end.

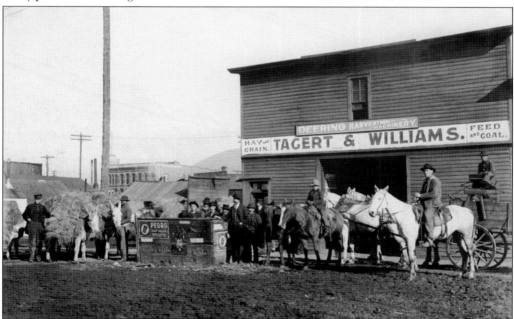

Pictured here is the Tagert & Williams livery barn, located at 600 East Cooper Avenue. This business was once the Themer and Smith Livery Barn. There is a large group of unidentified men posing in front of the building, some on horseback. On the left are several mules loaded with hay.

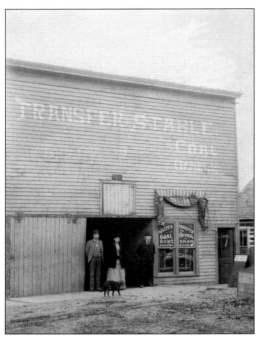

The Transfer Stable Coal Office is pictured here in 1885; above the windows are two signs that read "Aspen Transfer Coal Office, Robert Shaw, Proprietor." Standing in the doorway are, from left to right, Robert Shaw, Dora Shaw, and Preston Swan (Shaw's clerk). The office is on the south side of Cooper Avenue. W.G. Tagert, the Transfer Stable Coal Office, and similar businesses remained in business by expanding their services to include selling necessities like coal.

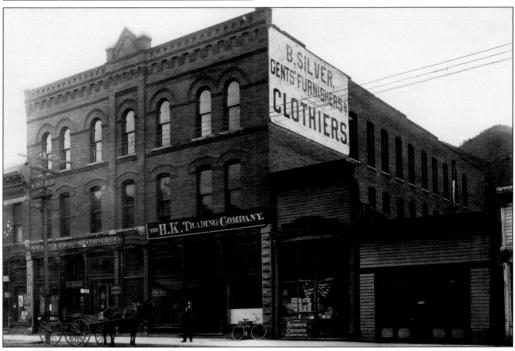

The Cowenhoven & Brown Block was one of Aspen's most premier business blocks, with the likes of the Cooper Book and Stationery Company, H.K. Trading Company, American Ladies Tailoring Company, Sanford's Fluid, Karl's Bread, and furnished rooms upstairs. The little wood building to the west is the Berg Confectionery, with an advertisement for Schrafft's Chocolates, the "Daintiest of Dainty Sweets."

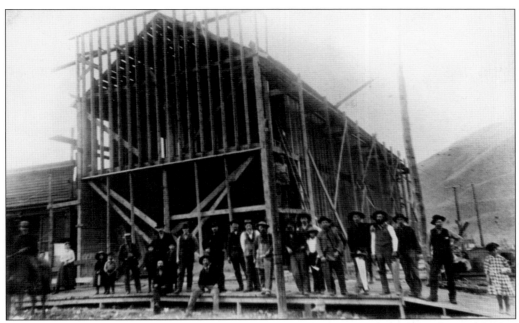

Gould Brothers Mesa Store was located at 500 West Main Street, on the corner of Fourth Street (north side of Main). There is an unidentified mother with her baby in a baby carriage, a horse and wagon, and a grocer standing outside the store. Red Mountain can be seen behind the building. Many commercial buildings of the day had a flat false front on them, including the building under construction. The building was owned by Edward Grove, Emmett Gould, and James Gould and sits approximately at Fifth and Main Streets to this day.

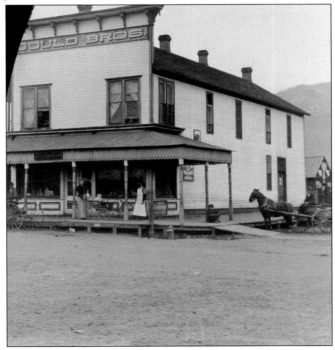

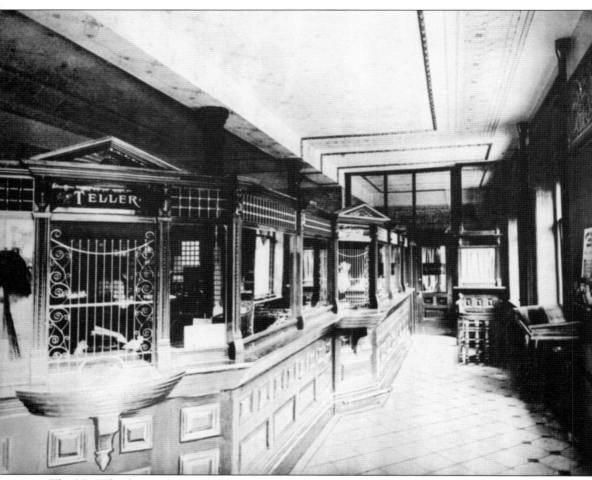

The J.B. Wheeler Banking Company was located on the southeast corner of the Wheeler Opera House. One of the first businesses Jerome B. Wheeler established upon his arrival in Aspen was the bank. Wheeler was as good at sizing up people as he was at seizing opportunities. Over the years, Wheeler invited his business associates to be a part of the bank as investors and members of the board. Membership changed based on Wheeler's opinion of the men he trusted or lost faith in. The bank remained a key business in Aspen up until the end of the silver boom, when, like many businesses of the time, the bottom fell out, and it ceased operations on July 10, 1893. During its peak, the bank specialized in "general banking in all of its branches, special attention to collections, sight drafts on all the principal cities of the United States and Europe, boxes to rent in its large and fire proof safe for the safe keeping of stocks, bonds, deeds, and packages of value."

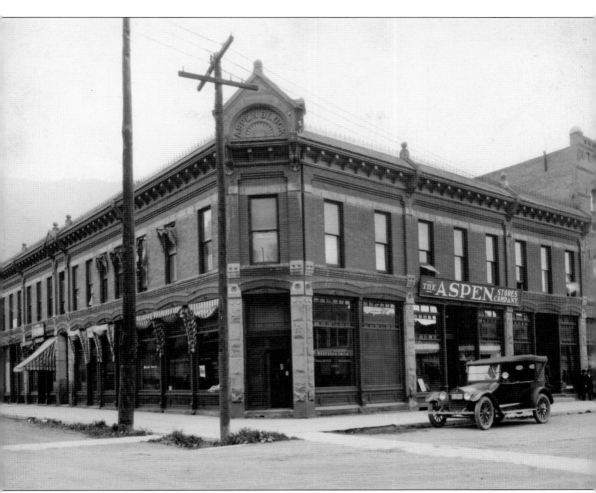

Pictured here around 1922, the Aspen Block was home to numerous businesses, including Manford Smith Real Estate, Insurance and Loans, which had a prime location on the ground-floor corner of the building. Dr. Twinning was located on the second floor, above Manford's office. The Aspen Stores Company is on the north side of the building, and a Ford Model A convertible is parked out front with the Colorado license plate "169-235 COLO 1922." The building is across the street to the west of the Cowenhoven Building and kitty-corner to the Elks Building. The Fashion Saloon, once owned in part by Wyatt and Josie Earp, is on the east side of the building.

Pictured here around 1885 is the front of the Bowman Musee and Saloon with a crowd of men out front, including Colonel Bowman on the far right. The window says "J.L. Bowman Musee," and a couple of signs are posted advertising P.H. Zang beers of Denver for sale at 10¢ per glass.

This is the back half of the interior of the Bowman Musee and Saloon as it appeared around 1895; the saloon was a long, narrow building two stories high. The lower floor was the saloon and museum, filled with all kinds of treasures from all over the world. There were few places to sit, so much of the drinking took place out back in the alleyway.

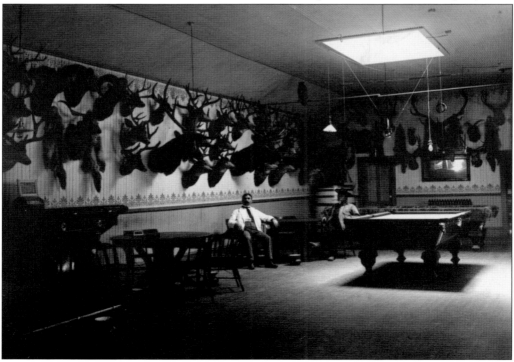

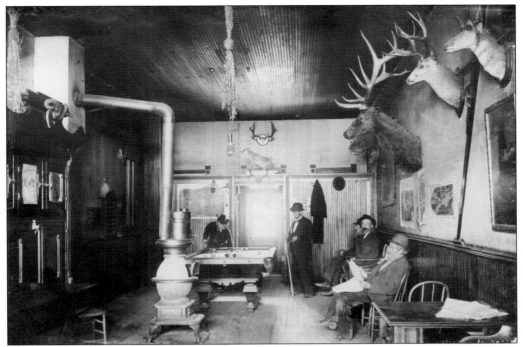

The front half of the saloon provided comforts not found in the rear, such as tables, chairs, and a potbelly stove. Colonel Bowman can be seen engaged in a game of pool with a group of unidentified onlookers around 1895. There is a sign on the wall that warns, "Pool for Drinks Only," as gambling was not permitted.

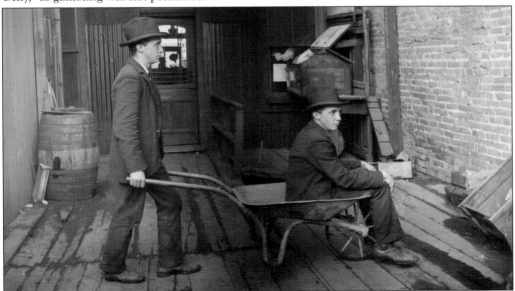

John Bowman Jr. was an accomplished photographer and won many awards for his trick photography. This 1901 photograph shows a man pushing a wheelbarrow in which it appears he is also sitting. It won a $1 prize from the *Denver Post*. Bowman said, "This is not a photo of a pair of twins, nor is it a gentleman paying an election bet. It is the extraordinary feat of a man wheeling himself."

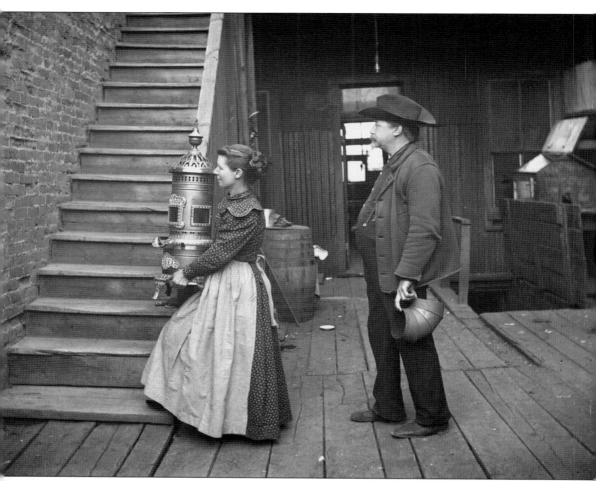

This is another trick photograph taken by John Bowman Jr. The woman, most likely Mary Bowman, is carrying a furnace with Colonel Bowman behind her holding the elbow pipe to the stove. They are in the back of the Bowman Musee and Saloon, possibly going up to John Bowman's studio. The Bowmans shared a photographic studio on the second floor of the Bowman Block, above the saloon.

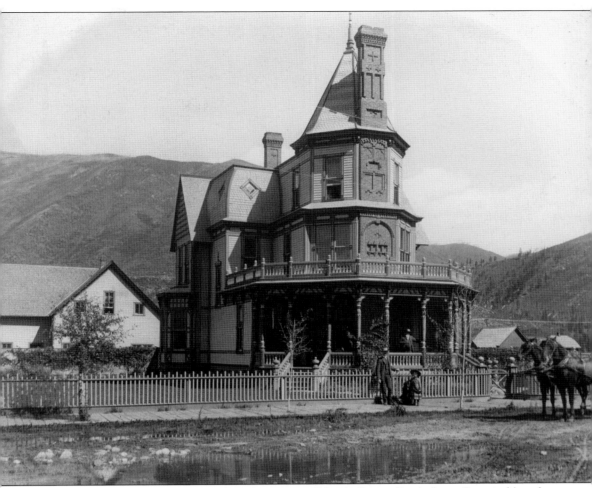

The Cowenhoven house was located on the corner of North Center Street (now Garmisch) and Hallam Street. DRC Brown later built a brick house on this site, which was eventually used as Aspen High School. The house in this photograph is wooden and has gables and a large turret at the front roof. It is three stories tall and has a large deck on the second story and a porch around the first. The house is surrounded by a wooden fence, and a boardwalk runs along the street. There are a man and a woman standing on the porch, likely Henry "H.P." and Margaret. The man with the child and dog is probably DRC Brown. A carriage or wagon sits on the right, partially out of the image. Red Mountain and Smuggler Mountain can be seen in the background.

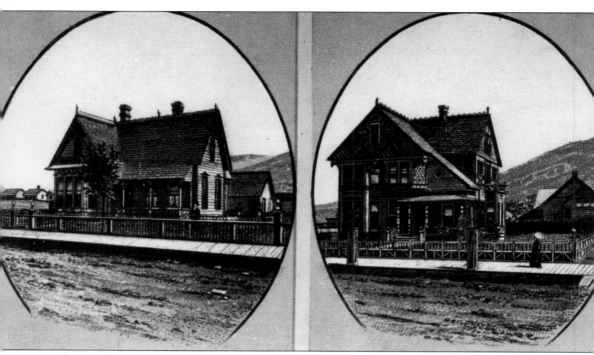

The residence of W.E. Turley is pictured on the left and the residence of E.T. Butler on the right. Turley was the owner of W.E. Turley Furniture and Housewares store. He boasted general housewares as well as inexpensive furnishings. Elmer T. Butler was involved in the mining business and owned a number of patented and unpatented claims around the Aspen area. His name appeared prominently in the local papers of the time due to the numerous lawsuits over mines and mining claims in dispute. He was a key business partner of Jerome B. Wheeler, H.B. Cowenhoven, and DRC Brown.

Pictured here is the Henry B. Gillespie residence, originally built in the 1880s with significant additions added later, including an upper balcony, dormers, and additional rooflines. Once the silver boom ended, the Gillespies moved away and abandoned the home. It eventually ended up in the hands of the Aspen School District. The years took their toll on the home, and people feared to go near it, thinking it was haunted and referring to it as the Ghost House. It was eventually leveled to make room for the addition of a gymnasium to the high school. In 1958, Neil and Paul Beck were hired to demolish what was left of the house.

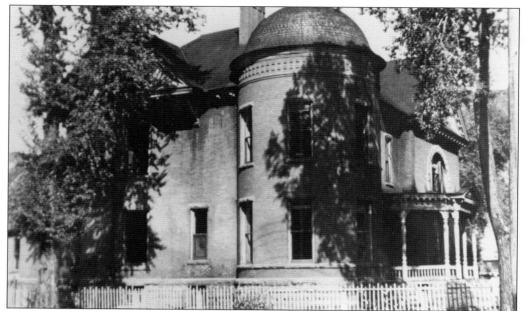

The DRC Brown residence on Hallam Street, pictured here around 1920, was later donated to the school district and used as the Aspen High School. It was eventually torn down and a larger red-brick school was built in its place, taking up nearly an entire city block. Prior to the Brown home, the Cowenhovens' mansion occupied this lot.

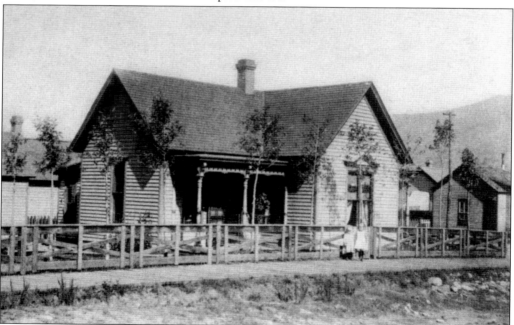

Pictured here is the Berg residence, located at 635 East Hopkins Avenue, on the corner of Spring Street and Hopkins Avenue. The two little girls in the front are believed to be Louise and Matilda Berg. It was built by Julius Berg and continuously occupied by the Berg family from 1881 until Louise Berg's death in 1971.

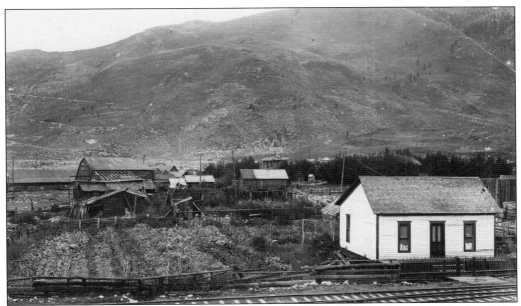

Oftentimes, homes would be built wherever a spare lot was available. Sometimes that would be next to the railroad tracks or right up against a mining operation. This photograph features some residences and vegetable gardens by the railroad tracks in east Aspen, looking toward Smuggler Mountain. The white house is located near Ute Avenue, and the building in the background has a sign that reads "Ute Smelter and Refinery."

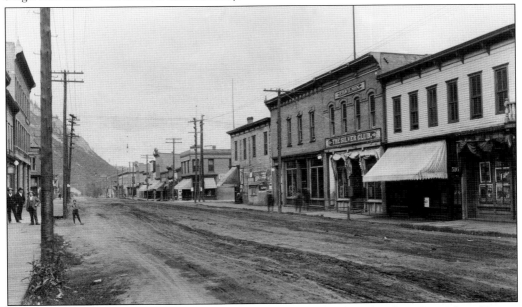

Pictured here in the early 1900s is Cooper Avenue looking west toward Galena Street from Hunter Street. The building on the right has a sign that reads "Ed Wilson" and "The Silver Club," along with a number of other businesses. Tomkins Hardware is across the street from a local grocery store with advertisements for Climax Plug Tobacco, Coors Beer, and basic necessities. Farther down the block is Tom Latta's Brick Saloon; in later years, it became the Red Onion.

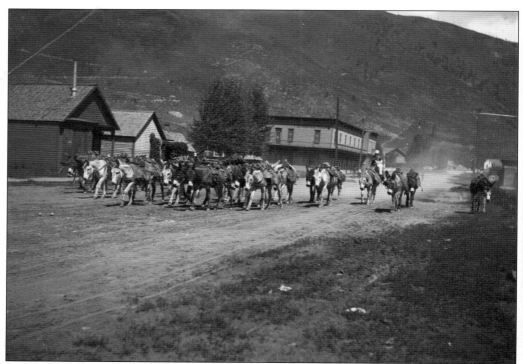

Around 1887, a pack train of approximately 20 jacks carries what appear to be empty panniers on East Hyman Avenue, just west of the Bailey Block. Smuggler Mountain is in the background.

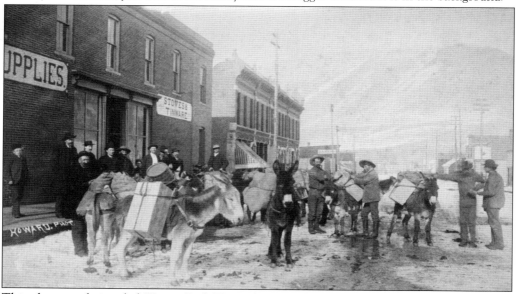

This photograph is titled "Burro Pack Train Aspen Colorado." The men and animals are on Galena Street next to Tomkin's Hardware. Due to the construction of the Keene Block, completed in 1887, the image can be dated to late 1886 or early 1887. This photograph is interesting, as it captures Galena Street before the Webber/Elks Building (1891) and the Cowenhoven Building (1890) were built.

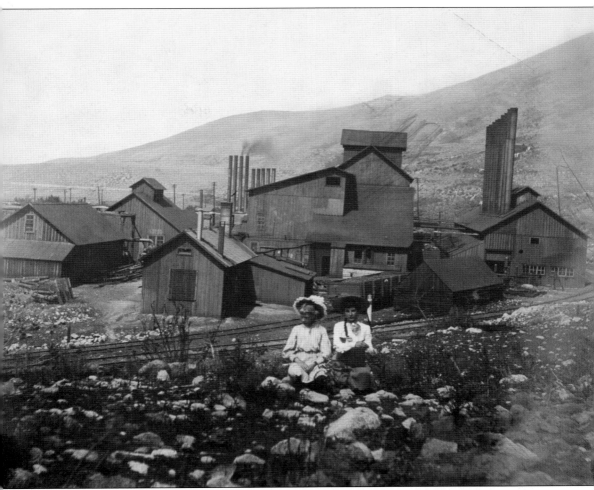

With mining and related industries taking over the valley, children and families alike had to integrate their leisure activities with their surroundings. Often the children would hang out near the mines or up on them unless they were chased away by the crews. Picnics in the shadows of the mills and mines were everyday occurrences, and everyone knew the importance of the mining activities on Aspen's future. This photograph is of Bertha Kelly (left) and an unidentified friend in front of the Mollie Gibson Mine on Smuggler Mountain. There are railroad tracks behind them, and the mine buildings are clearly visible in the background.

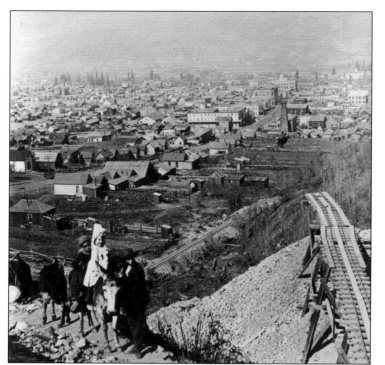

In this view from Aspen Mountain, a girl and a boy are riding on a burro while a third boy stands next to them on the narrow trail around 1890. Below the children, the Mill Street area of town is clearly visible with the Hotel Jerome, Wheeler Opera House, and Clarenden Hotel easily identifiable. Also visible are the Horse Tramway tracks below for the Aspen Mining and Smelting Company.

The hustle and bustle of downtown life on Mill Street is captured here from Hyman Avenue. A note on the back of the photograph says that there is electricity, so the image is from after 1888 but before 1892, as the Emmett Building has not yet been built and is not visible in the photograph.

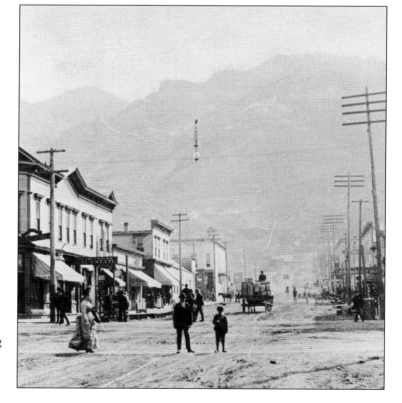

Pictured here is Mill Street, looking north from about Durant Street. There is a girl on a donkey in the foreground with two boys standing nearby, the same children photographed up on Aspen Mountain on the previous page. The large sign is advertising the Clarendon Hotel. The image was photographed and published by B.W. Kilburn around 1890.

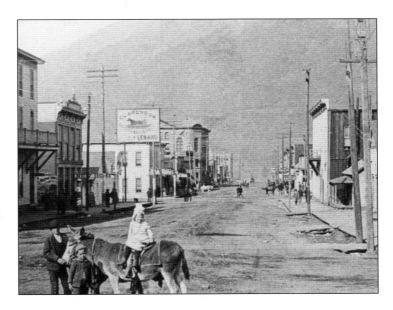

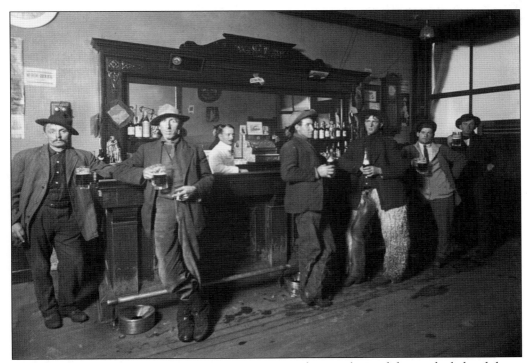

Pictured here is a crowd of unidentified young men standing at a bar with bartender behind them. In the background is a sign that reads, "No credit given here." Note the spittoons on the floor and the man wearing sheepskin chaps. The photograph was taken at about 5:00 pm on a summer day in Aspen between 1890 and 1900.

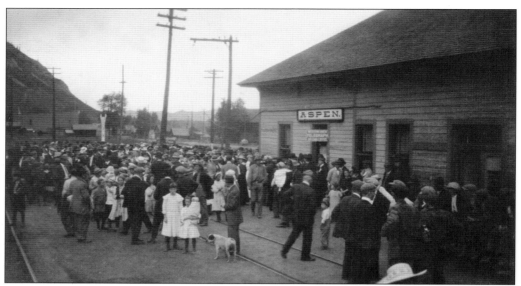

A large crowd gathers at the Colorado Midland Depot sometime between 1914 and 1918 to send off some of Aspen's finest to go represent the United States in World War I. A caption with the photograph reads, "Crowd at depot for the departure of Aspen's first contingent."

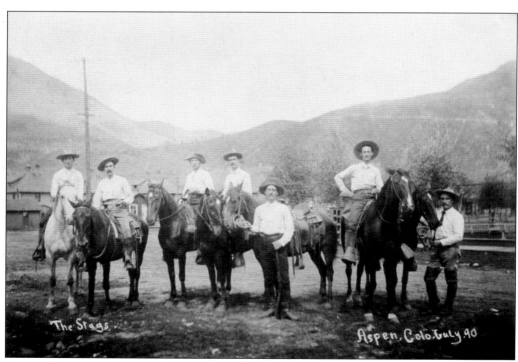

Pictured here around 1890 are seven men believed to be the Stags with their horses at the intersection of Durant Avenue and West End Street. The Garfield School is behind them along with other houses and part of Smuggler Mountain and Red Mountain in the background. The Stags were a local ranching family.

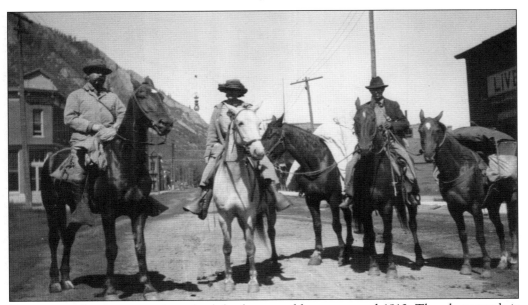

Two men and a woman on horseback lead two packhorses around 1910. The photograph is captioned, "On the way to Twin Lakes," and was taken in the 500 block of East Cooper Avenue with the LaFave Block in the background along with Shadow Mountain. They are apparently just setting off from Aspen. An arc lamp can be seen hanging in the background.

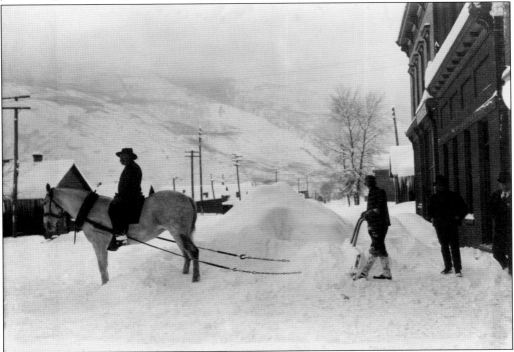

Men and a horse plow snow in front of Bowman's saloon. Bowman may be the man riding the horse pulling the snow scoop in the front of his building. The other men were most likely standing around to render unnecessary advice, hoping for a free beer out of the deal.

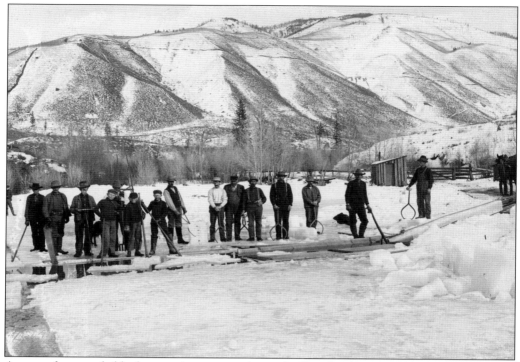

A team of men and older boys cut ice on a pond near the Slaughterhouse Bridge along the Roaring Fork River around 1900. Many of them are holding ice-cutting tools like tongs, saws, and prods. Ice was also harvested from Hallam Lake. Smuggler Mountain is in the background.

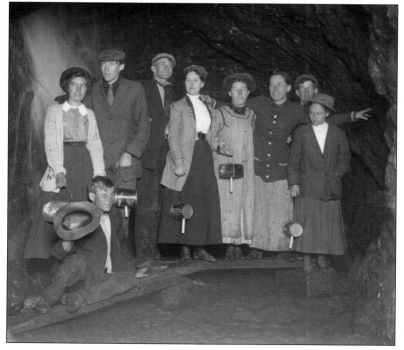

Mine tours were very commonplace. People even dressed up for the occasions. Any time a mine reported a big find or something out of the ordinary, like a hidden cave or waterfall, people lined up to go in and see the discoveries. The Durant Mine had a waterfall about a mile into the mountain, and locals took many tours into the mine to go see it.

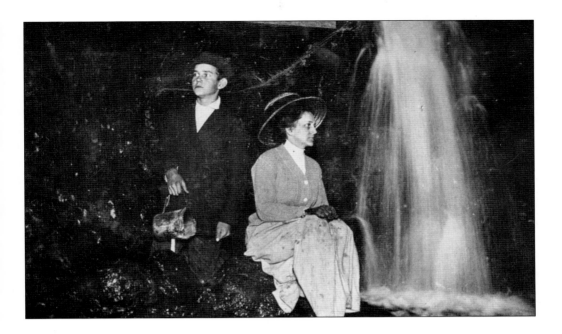

About a mile into the Durant Mine, a waterfall and flowing river was discovered, and tours of the waterfall went on for years. Due to the location of the waterfall, mining operations continued on without issues by simply going around it. The water flowed at over 1,500 gallons per minute but drained out naturally below. No one knew for sure where the water flowed out or how deep the drainage was. Pictured here around 1910 are Irving Adams and Effie Whinnery of Muncie, Indiana, sitting to the left of the waterfall.

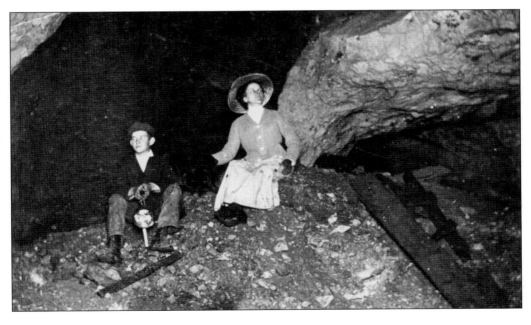

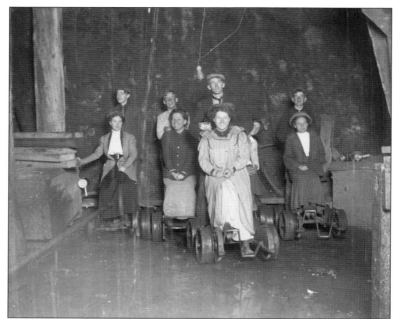

Around 1910, a group of nine people pose in the interior of a tunnel in the Hope Mine. They are standing on self-powered mine cars (pedal cars), with two people on each one. Among them are Evelyn Woom Gilbert and Ben and John Gilbert.

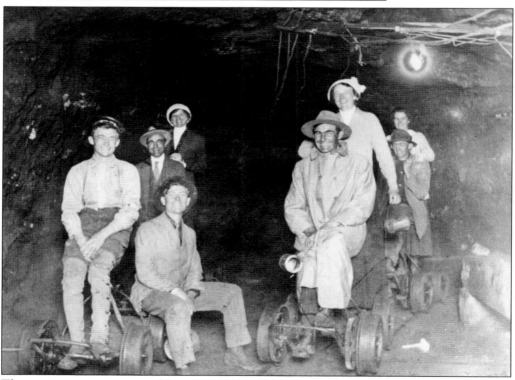

These mine tourists pictured between 1910 and 1912 are, from left to right, Jesse Newland, unidentified, and Otto Zaugg; (second row) Billy Zaugg and Minnie Rockefeller; (third row) Ida Rockefeller Terrill and Howard Demaris; (fourth row) Mabel Pierce. Ida and Minnie were sisters of Elizabeth Rockefeller Beck, the author's great-grandmother.

The Rink-Rink Opera House is pictured here around 1885 with several people standing in front, and Aspen Mountain in the background. Church meetings and public gatherings were held here, and it was one of the first opera houses in Aspen. It later became the Tivoli Theater, located on the corner of Cooper Avenue and Monarch Street.

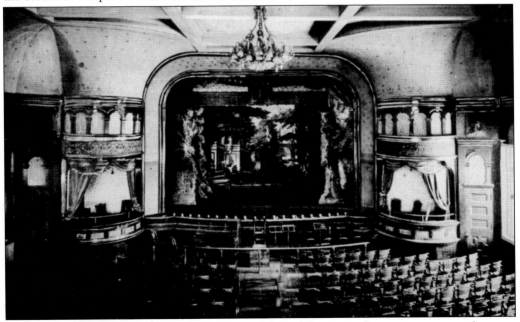

This is an interior view of the Wheeler Opera House Theater, a three-story stone-and-mortar building that possessed the latest and greatest stage equipment money could buy. The main floor was home to the J.B. Wheeler and Company Bank as well as other businesses, including John A. Beck Fancy and Staple Foods. The second floor was the stage level for the theater, and this photograph was taken from the balcony.

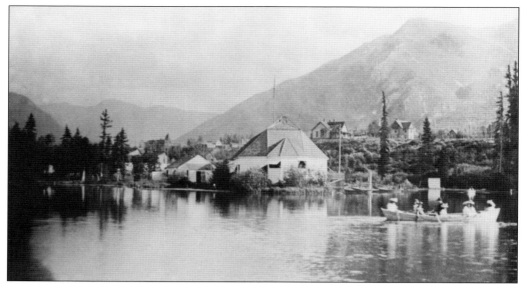

Hallam Lake is situated just north of the downtown area, and became the locals' social and entertainment venue in the summer months. Charles Hallam even had a dance pavilion built at water's edge. Locals were allowed to put small boats on the lake, and swimming was a favorite summer pastime for everyone. Big and small bands alike played there in the cool evenings. Local ethnic groups such as Bavarians, Italians, and even Lithuanians held their social gatherings in the pavilion. After the silver boom ended and Charles Hallam's fortunes dwindled, he donated the land and the lake to the city to ensure access to it for everyone. As time went by, the city could no longer maintain the buildings, and the land was put up for sale. It was purchased by DRC Brown, who closed it off to the public.

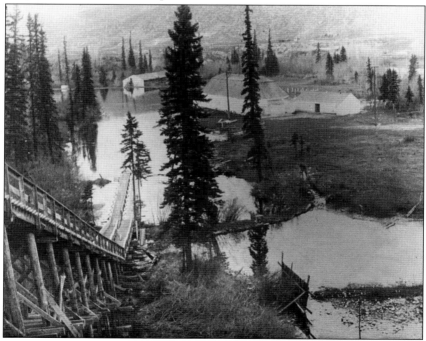

# *Four*

# EVENTS, DISASTERS, LAWSUITS, AND DISCOVERIES

Early Aspen recorded a number of major events, among them the lawsuit of the century between miners who felt they owned the vein of ore from the apex (surface) down into the earth no matter where it went and the sideliners, who felt they owned the ore vein once it crossed into the boundaries of their claims no matter how deep. In the end, the apex camp won the case over the sideliners. The lawsuit even involved jury tampering and death threats.

There were other major events that helped shape Aspen over the years. One notable event took place when a number of mine shafts running under the streets of Aspen collapsed. Right above them were the Colorado Midland Rail Yards. With the collapse of the shafts, a big hole opened up, engulfing a number of steam locomotives and railroad cars. The hole was deep enough that attempts at retrieving the locomotives and cars were fruitless. This hole became known as the Glory Hole, and it remained unfilled for decades. It became a town dump with constant fires; people threw in their trash and coal slag from fireplaces and furnaces and vandalized the site.

In 1893, on the fifth level of the Smuggler Mine, a vein was discovered that was almost pure silver. As miners followed the vein, they discovered a small room known as a vug, and its walls glistened with silver. Hanging precariously in the ceiling was a nearly two-ton solid piece of silver. This is believed to have been the richest silver discovery of that time.

The Clarendon Hotel, Aspen's finest hotel at the time, burned to the ground in 1884. The new Clarendon Hotel was built in the same location and included a number of improvements for fighting fires as well as providing additional creature comforts.

The death of Fanny Chambers, one of Aspen's most notable sporting women, in the fall of 1884 led to an elaborate funeral attended by a dozen or so other soiled doves as well as the sporting community in general.

Bruiser the mastiff is pictured here. On March 10, 1884, a snow slide occurred in Conundrum Gulch that took the lives of five men. Within hours of the avalanche, a group of friends dug through the snow looking for the men buried 25 feet down in what was left of their cabin at the Southern Hope Mine. All five men were located and removed from their icy graves. Bruiser's master, J.M. Thorne, was among the dead men. Virginia I. Bevier, who may have been related to one of the dead men, had a trunk buried in the cabin she felt compelled to dig out. While searching for the trunk, 33 days after the incident, they found Bruiser hiding under a bed. The citizens of Aspen were so enamored with Bruiser's survival that a commemorative silver collar was commissioned and completed by J.E. Freeman and company, inscribed, "Forwarded to Samuel Thorne and Miss Libbie Thorne, by the citizens of Aspen." Following commemorative photographs and celebration, Bruiser was returned to surviving family members in New York City.

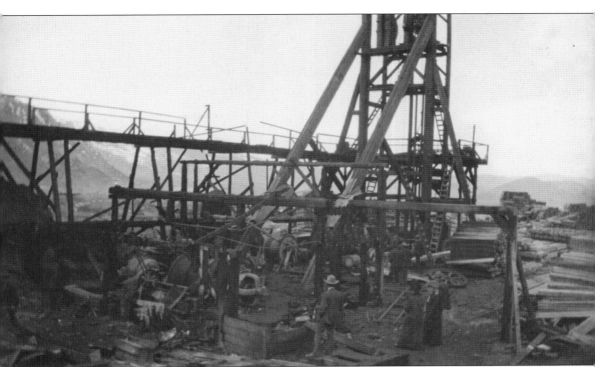

The Free Silver shaft house burned down on April 28, 1914, and only the head frame was left. The electric system was destroyed, and the backup Smuggler steam-powered pumps were then used until 1918. A caption with this photograph reads, "Wreck of the Free Silver shaft after fire." This mine was part of the Mollie Gibson and Smuggler Mine complex, and the effects of this fire would be felt over a year later, when debris from the fire fell deep into the mine and fouled the pumps used to drain the smuggler mine in an effort to restart mining operations. The fire was caused by a lightning strike, and by the time the fire had burned out, little was left of the four-story mine structure.

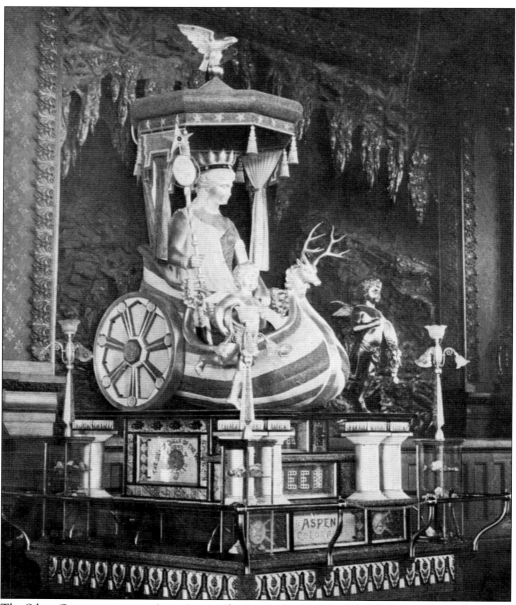

The Silver Queen statue was Aspen's contribution to the Chicago World's Fair in 1893. The statue stood near the Coal King in the Pueblo Mineral Palace, disappearing during World War I and the war effort to recycle minerals. It was supposed to be displayed in Denver but never made it there. The image appears to be printed on a page from a magazine. On the back is a list of names for the annual board in 1920. The mystery of the disappearance of the statue has intrigued people for years, and some believe she still exists, buried in some basement or cave. The silver boom ended just about the time she was to be sent off to the World's Fair. Some images of her taken at that time showed slight differences in her size or ornamentation on and around the statue, leaving people to conjure up more conspiracies than fact.

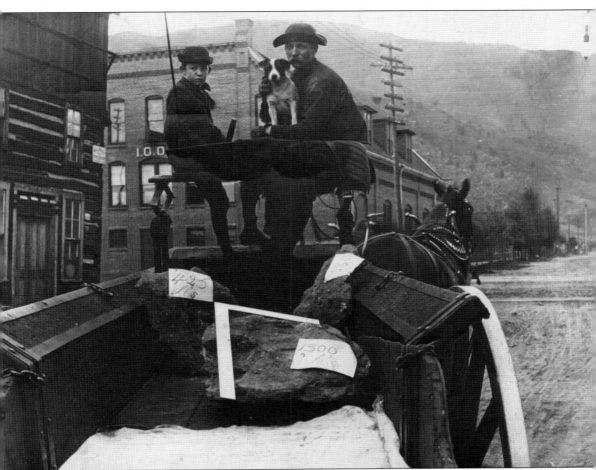

Some of the biggest silver strikes in history took place in Aspen. First the Mollie Gibson reported a major discovery only to be outdone by the adjacent Smuggler Mine in 1894. This photograph is of a man, boy, and dog riding on a horse-drawn wagon that is carrying three large nuggets of silver. The boy is Joseph H. Hicks, who worked as an office boy. The chunks in the wagon are pieces of the largest silver nugget ever mined, which had to be broken apart for removal from the mine and transportation. The IOOF (International Order of Odd Fellows) building is in the background, now city hall. A visible portion of the horse's harness reads "Smuggler." This was believed to be the greatest silver discovery of its time, although there was some question if that was true based on discoveries elsewhere in the world in the same time period.

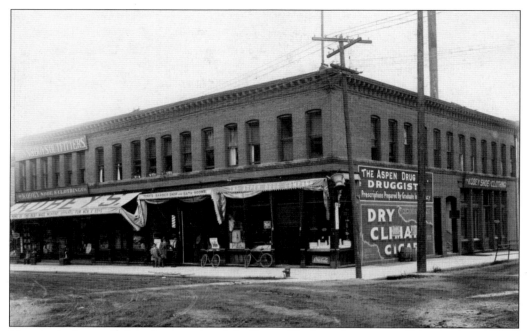

Here are before and after photographs of the Keene Block on the corner of Hyman Avenue and Galena Street in the early 1900s. The first photograph was taken in the early 1900s in the summer months. Marx Kobey's Shoe and Clothing Company and the Aspen Drug Company were the primary tenants in the building at street level, along with a barber shop. The second floor was filled with apartments. A fire broke out on Thanksgiving 1919, and the building was destroyed. Fire was always a fear in Aspen due to limited availability of the resources needed to fight them. In these two images, one can see how damaging a single fire could be. Even brick structures were vulnerable as a result of the inadequate resources.

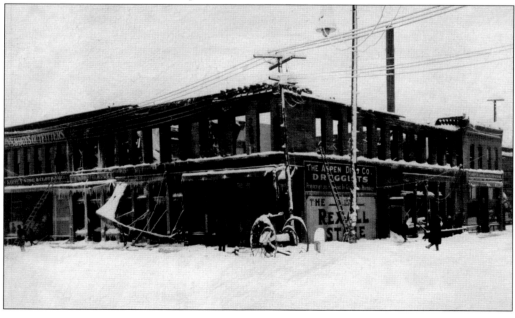

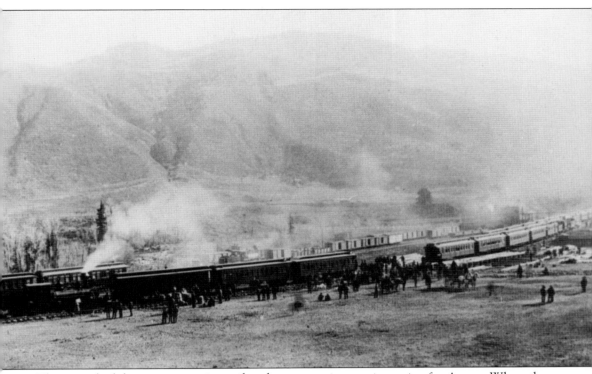

The arrival of the two competing railroads was a major turning point for Aspen. When the narrow gauge Rio Grande Railroad first pulled in, a few weeks ahead of the Colorado Midland, parties ensued, with few notable Aspenites missing. Jerome B. Wheeler was a big investor in the Colorado Midland, and although the biggest party of them all was held in the Wheeler Opera House, Wheeler was noticeably absent. Pictured here is one of the first trains into Aspen, arriving on November 2, 1887. At left is engineer George Moore at the throttle of Engine 52, switching three cars, the first of four specials to arrive on the evening of November 1. Behind the 52 are two business cars occupied by general superintendent and chief engineer R.E. Ricker and staff. To the right, engines 172 and 32 head a five-car train, including four narrow-gauge Pullmans. Mostly hidden at far right is the 11-car special handled by engine 248, having arrived late for more festivities.

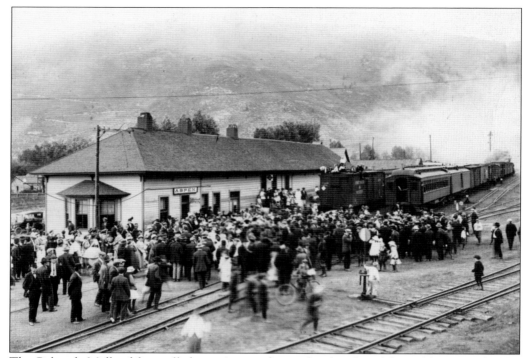

The Colorado Midland first pulled into Aspen a few weeks after the celebrated first arrival of the Rio Grande. The Midland was on schedule to get to Aspen first by a few weeks but the train was held up just outside of Aspen waiting on supplies to complete the two bridges needed to cross Maroon and Castle Creeks. Pictured here is a large crowd at the Midland Depot.

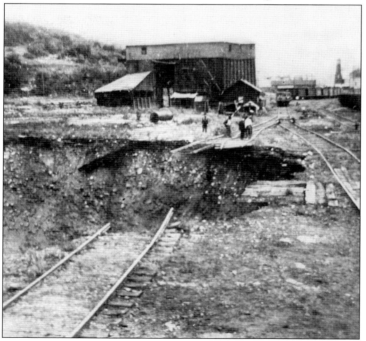

In August 1918, a mine shaft deep below the surface of the valley running beneath the streets and railroad tracks collapsed. The Glory Hole, as it was called, was massive and encompassed at least three sets of tracks and most likely engulfed some railcars and a locomotive or two. So deep was the hole that anything that fell into it was lost for good.

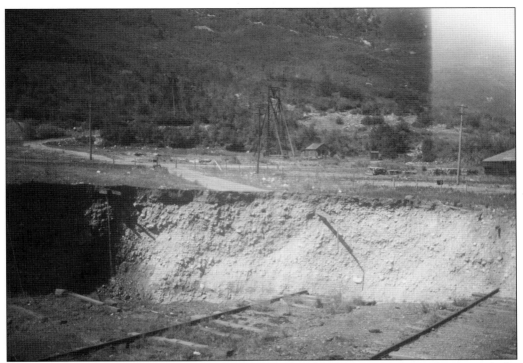

The Glory Hole became the town dump, and all matter of trash was tossed into the gaping hole. On occasion, fire crews were called to put out fires in the hole caused by a careless person who tossed old, still-hot clinkers (burned coal slag) into the abyss. Eventually, the holed filled up with water, and a park was created, parts of which still exist today.

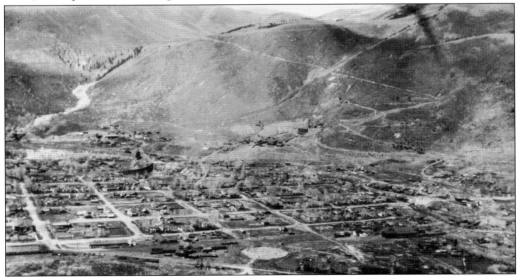

In this photograph, taken from Aspen Mountain in 1923, one can see the size of the Glory Hole (bottom center). Although it looks like a round vacant lot, it was actually quite deep. Many worry to this day that another sinkhole could appear, as Aspen is riddled with mine shafts and caves below ground. Engineers suspect that they are all flooded.

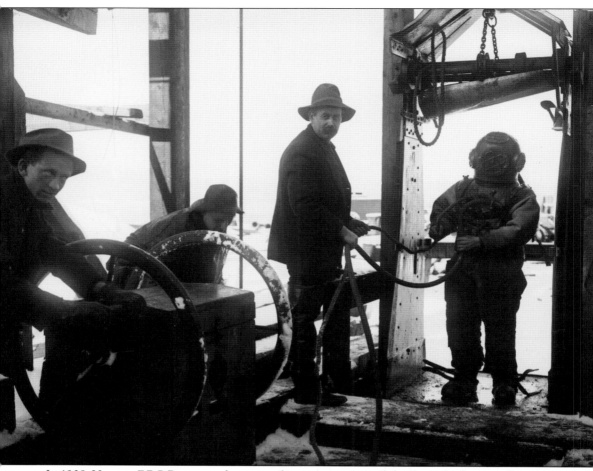

In 1908, Hyman, DRC Brown, and a group of investors organized the Smuggler Leasing Company to resume mining operations. Silver prices had stabilized, and the investors felt they could make a profit. Pumps were installed on the 12th level, around 65 feet deep. The investors believed that by getting the pumps started they could combat the nearly 1,500 gallons of water pouring into the mine every minute. Although the pumps were at the 12th level, an air line for them was installed up to the ninth level, which was not underwater. On the first try, one of the pumps started up and ran for nearly 24 hours. Divers were called in to see if they could go down and pack the pumps. While the pumps were running, some debris from the burned-out Free Silver Mine fouled the intake lines, grinding the pumps to a halt. It took two months for the divers to get them working again. Mining operations resumed and continued for a few years with limited success. By 1907, all mining operations had ceased.

# Five

# ASPEN BECOMES A CITY

Aspen was originally controlled by a group of small but powerful companies. They platted the streets, city blocks, and residential neighborhoods, determined the cost of each lot, and installed some rudimentary infrastructure such as ditches, sidewalks, streets, and even toll roads to access the valley. Henry B. Gillespie was the first to see the value in controlling the land. He conceived the town of Ute City, to be owned by his company, the Roaring Fork Improvement Company. Gillespie went to Washington to acquire city status and even postal services, but in his absence, B. Clark Wheeler, a self-promoter of extraordinary skills, arrived and staked out the town, renaming it Aspen under the Aspen Town and Land Company.

The lots sold quickly, and building began in earnest in 1881. Soon the downtown area was filled with thriving businesses. Grocery stores, furniture stores, drugstores, saloons, and hotels sprang up almost overnight. Miners and prospectors came with their families, filling flop houses, cabins, and hotels to capacity. To support the bachelor populations, the sporting women were not far behind. Soon, the Little Nell area at the base of Aspen Mountain on Durant Avenue boasted numerous brothels, close to the saloons over on Cooper Street. When the railroads eventually arrived in Aspen, the Colorado Midland's station was built on Deane Street, only one block from the brothels. Many felt the arriving and departing women and children should not have to pass through the red-light district. The saloon girls agreed to move their business to less visible locations. Some believe the move was also a way for wives to keep an eye on their husbands, as the houses of ill repute were no longer near the saloons (it was not acceptable for proper women to be in the saloons).

With this influx of people, Aspen needed an advanced infrastructure to support it. This included water, electricity, sewer systems, and eventually telephone and Western Union telegram. Battles ensued between the land companies and a fledgling local government regarding who should or would provide these services. Eventually, the local government won out.

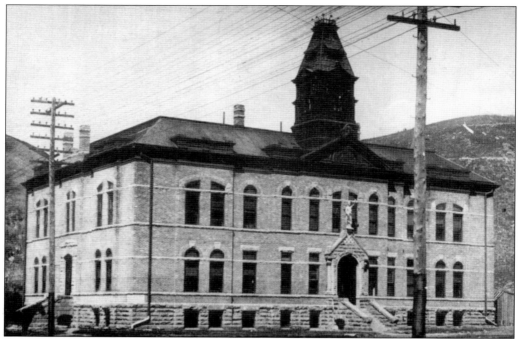

Pitkin County Courthouse is pictured here shortly after its construction in 1891. In order for any respectable city to survive, it needs an infrastructure to support its growing population, and amenities such as hotels, government offices, a fire department, power, water, and a police department, to name a few.

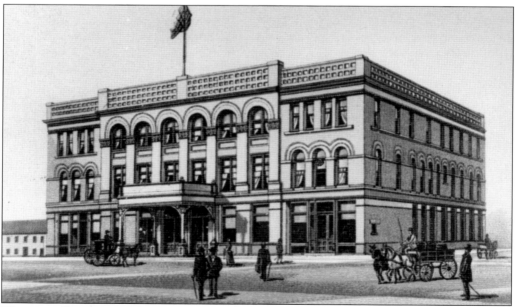

This is an illustration of the Hotel Jerome from about 1900. When construction was completed in 1889, it became Aspen's first and only five star hotel and was the centerpiece of Aspen's high society.

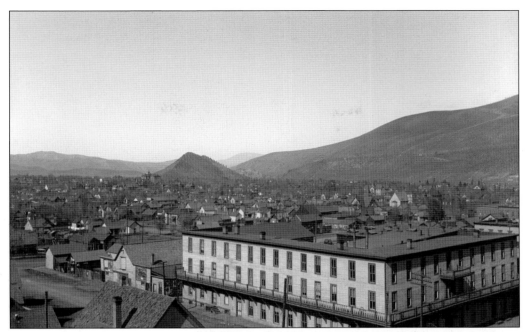

Pictured here is the Aspen Clarendon Hotel on Mill Street, with the rooflines of town behind it. One can also see Red Butte and Red Mountain and the Washington School off in the distance. By this time, Aspen's population was near its peak.

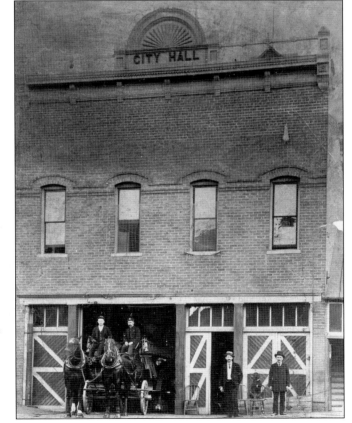

Early on, the Aspen Fire Department was headquartered in the city hall building. The fire stations were distributed throughout town not only to provide a sense of security and quick responses for fires, but also to engender healthy sporting competitions between the various fire crews.

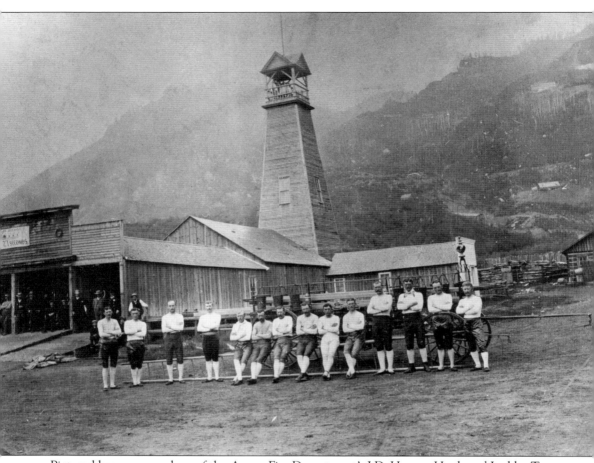

Pictured here are members of the Aspen Fire Department's J.D. Hooper Hook and Ladder Team in the 1890s. They are all wearing matching shirts and pants, presumably the outfits they wore for hook-and-ladder competitions. The fire tower is behind them with the bell at the top, which was donated by Col. H.B. Gillespie. They are leaning on a ladder, with the fire wagon behind them. The sides of the wagon are lined with buckets for water, and "J.D. Hooper" is printed on the side. The sign on the building depicts a wagon crew in competition with "Record Breakers 27 seconds" printed on it. Aspen Mountain is in the background. This photograph was taken early in Aspen's history, as many of the trees still stand on the mountain, and the major mining structures have not been built yet.

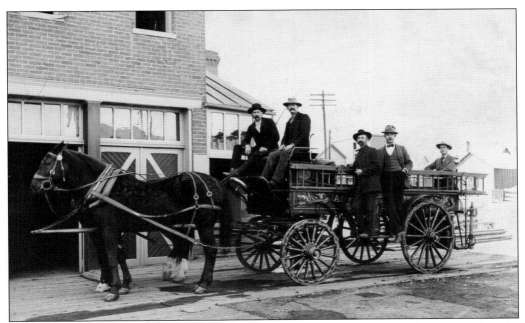

Members of the Aspen Fire Department pose on a wagon with their company's name on the side, pulled by a team of two horses. This crew was most likely from the main fire station at the Aspen City Hall, which was originally an armory and fire station. It was located at South Galena Street and East Hopkins Avenue.

Pictured here is a team of white horses pulling an Aspen Fire Department J.D. Hooper Hook and Ladder Company wagon. There are five men on the wagon, which is stopped in a street in front of a brick building. From left to right are unidentified, Tom Beck, John Beck, Pat Rolland, William Wack, and Klondike McDonald. The Becks are the author's great-grandfather and great-uncle.

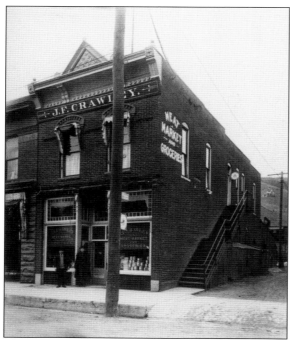

When telephone service was implemented in Aspen, almost everyone signed up. The telephone company published a phone book with a list of rules of telephone etiquette—profanity was the worst offense. Callers were reminded to keep their conversations brief to make lines available to others. The first telephone office was located above the J.F. Crawley Grocery in the Weinberg Building at 208 or 230 South Mill Street.

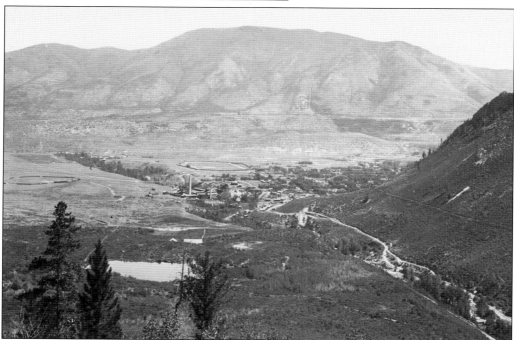

In this panoramic view of Aspen from the southwest, on the left is the baseball field, in the background are Red Butte Cemetery and the racetrack, and in the middle is the Holden Lixiviation Plant. In the foreground are Castle Creek and the road to Ashcroft. Castle Creek and the pond in the foreground fed the system installed to provide drinking water and supply water to newly installed fire hydrants.

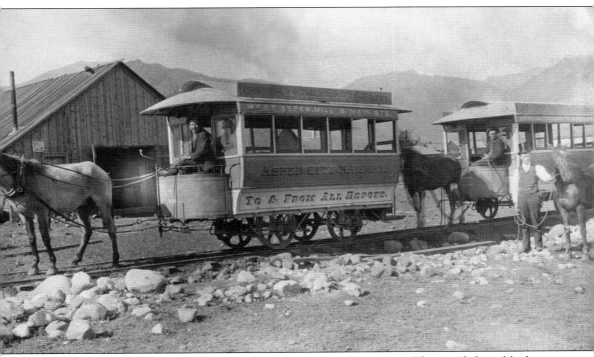

The Aspen City Railway was a fairly modern convenience for its time. The city fathers felt that in order for Aspen to compete with other major metropolitan cities, it needed the conveniences found in them. With funding, a series of lines and depots (stops) were installed in the years leading up to 1885. Pictured here are two of the horse-drawn trolleys on rails, with a man and horse standing to the side at right. The first trolley reads, "West Aspen, Mill & Main Sts," "Aspen City Railway," and "To & From All Depots," and an advertisement on the top of the trolley touts "Fashionable Sand's Bro's Clothiers." The front trolley is No. 1, and the second appears to be No. 2, visible above the heads of the trolley operators.

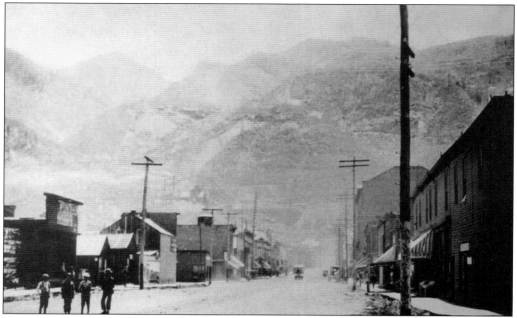

This photograph of Mill Street looking south toward Aspen Mountain portrays people, carriages, and the Aspen Street Railway (trolley). The Wheeler Opera House is on the left, and the photographer is standing on the corner of Main Street. The two-story wood-framed building in the right foreground is most likely the old LaFave Building, erected in 1885 by Frank LaFave.

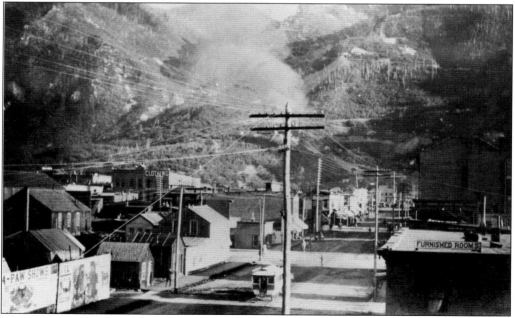

This photograph of the downtown area, including the Aspen Street Railway trolley, was taken from the roof of the Hotel Jerome looking south on Mill Street. The 4-Paw Shows, otherwise known as the 4-Paw Menagerie, is advertised on the side of a building. Aspen was a favorite for all the traveling circuses of the day.

Pictured here around 1888, Hunter Creek Power House was the first hydroelectric plant to power a community in the United States. Originally, it provided direct current to the Smuggler, Mollie Gibson, and the Della-S Mines. As capacity was expanded, it provided power for other applications, including the arc lamps over the city streets. Eventually, it provided alternating current and direct current throughout the town and to the mines.

Construction on the Castle Creek Hydro-Electric Plant began in 1892. This plant was designed to produce alternating current and direct current power, but ultimately everything was changed over to AC only. Water to power this plant was provided through a number of ponds, tanks, and flumes from Castle Creek.

Demand for electricity continued to expand, and by 1918, a new, more powerful General Electric generator was delivered to Aspen for installation. It took a team of men and horses to deliver the GE generator to the Castle Creek power plant from the railroad depot.

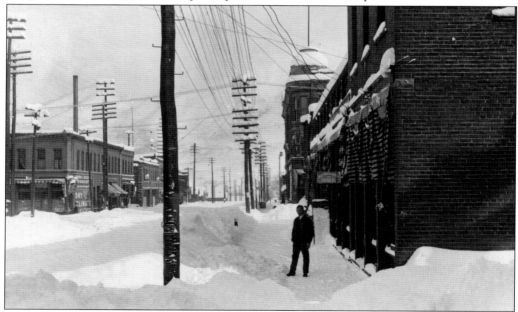

Galena Street looking north is pictured here after a heavy snowstorm. Prior to newer technologies, power distribution was largely a point-to-point proposition requiring numerous power lines throughout the city. Power poles carried both AC and DC power lines as well as telephone and telegraph. Spacing between poles as well as on the poles was a challenge and often caused issues with the various types of usage on the wires.

Galena Street is pictured here during a snowstorm. On the left is the Tompkins Hardware Building as well as the Aspen Block building; on the right are a number of smaller buildings and businesses. Utility poles are plentiful on the street.

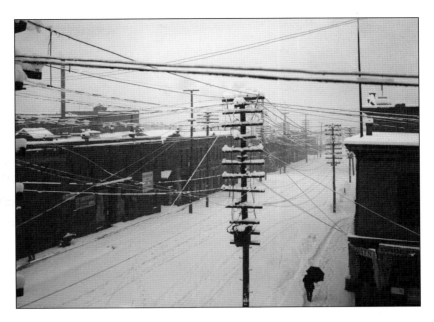

The Elks' band is pictured here playing in front of the Aspen Elks Building at Galena Street and Hyman Avenue. One of the new arc lamps can be seen overhead. By 1925, all of the old lamps needing trimming each day had long been replaced.

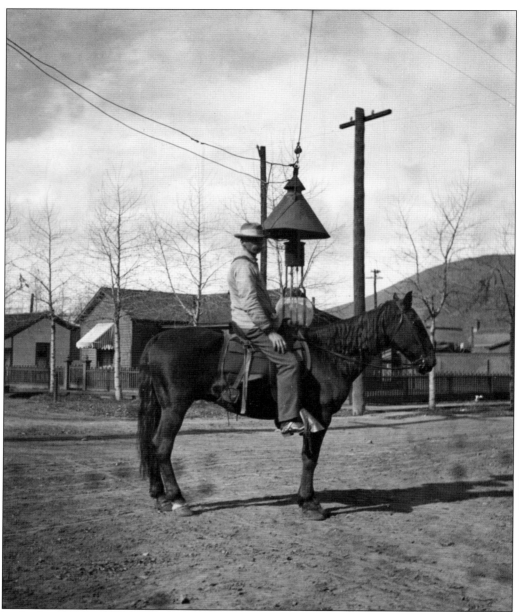

In the late 1880s, Aspen's streets were lit up with a new technology known as carbon arc lights. Installation of these lights earned Aspen the distinction of being the best-lighted town in the United States. Aspen was one of the first American cities to light its streets with electric-powered lighting. Each evening, Charles Reuter (pictured) would ride his horse around town, trimming each carbon electrode in the lights and starting them up one by one. The nightly process became so routine that the horse knew the route, and all the rider had to do was lower the light, trim it, and raise it back into position. These lights were supplied with DC power and would stay lit until early morning, when the power company would simply cut the power just in time for sunrise. By August 1, 1894, the Roaring Fork Electric Light and Power Company furnished newer, glass-enclosed arc lights and billed the city $5 per month per light; trimming the lights was no longer needed.

# Six

# SOCIAL ORGANIZATIONS, RELIGIONS, AND SCHOOL LIFE

As Aspen's population grew, so did the number of social organizations, churches, and schools. There was a social class system of the "haves" and "have nots." There was a distinction between those who brought wealth with them versus those who made their fortunes after arriving. A person's nationality, marital status, or both played a part in where one stood in the community. The age-old conflict of working class versus the social elite seemed to exist almost like a birthright for entry into Aspen's society.

All of this played into everything from where one lived in the community to where one picnicked. Clubs based on religion were common. Whether one spent only summers in the valley or lived here year-round played a remarkable role in social status.

Biracial people were as welcome as the blacks, Europeans, and Hispanics. And children would likely have had no issue with Asians had they been welcome in the valley.

The types of sports played could inadvertently put a person into a particular social class. Boxers were in one class, while baseball players were in a different sphere. A close look at the many fraternal organizations reveals who was welcome and who was not. Union membership or local newspaper of choice revealed much about an individual's lot in life.

Aspen had a number of schools—the Garfield School located in the West End, the Washington School, and former DRC Brown residence high school, which was closer to the downtown district. Aspen had two notable churches that have stood the test of time—the Community Church, originally founded as a Methodist church, and St. Mary's Catholic Church. Other churches at some point in history fell victim to failing membership.

Aside from churches and schools, Aspen boasted many social organizations. There were sports clubs like the Aspen Baseball Club. Aspen had all the political parties represented, and there were even clubs for the former Confederate and Union soldiers. If one could think of it, Aspen had a club or social organization for it.

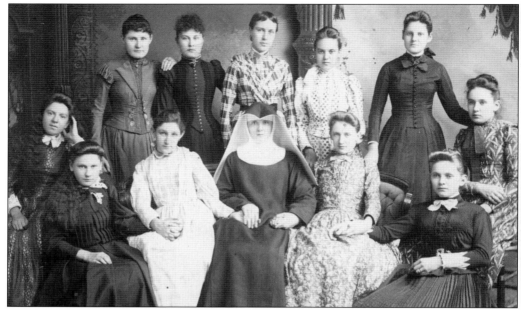

This is a studio portrait of a group of 12 women, including a nun. Aspen was home to a Catholic convent for a number of years between the 1880s and early 1900s. Although many religions were represented in the valley, the Catholics outnumbered all others by a large margin.

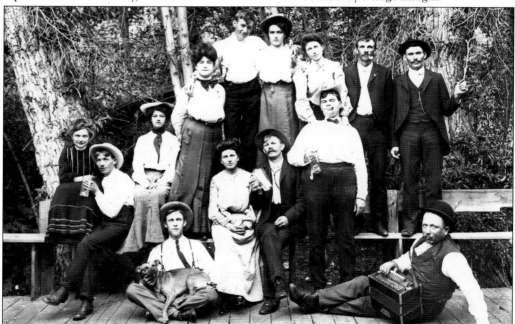

A group of people at the Slovenian Dance Pavilion in east Aspen is pictured here. The ethnic groups that could not afford their own dance hall or pavilion would use the dance pavilion at Hallam Lake or one of the many local churches. Aspen had numerous nationalities represented in the valley from a very early time, including Italians, Germans, Irish, Swedes, and other western Europeans.

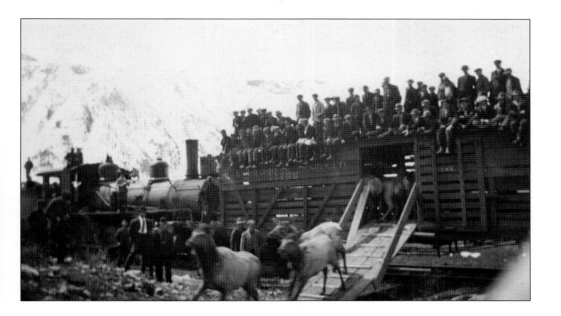

From the time that the Indians still lived in the Roaring Fork Valley through the early years of the 1900s, people lived off the land and often hunted for food. With the massive influx of people into the valley following the 1879 discoveries of silver, overhunting of the indigenous animals and fish was destined to happen. Most notably, the elk populations in the area dwindled to the point of local extinction. In 1913, the Aspen Elks lodge decided to reintroduce elk into the valley. A large herd of elk was loaded into a Colorado Southern boxcar and delivered to Aspen, where they were unloaded at the base of Smuggler Mountain and set free. A large crowd of Elks members and locals gathered around as the elk were unloaded. Over time, the population of elk in the valley returned to a healthy level, with better management of the herds and hunters alike.

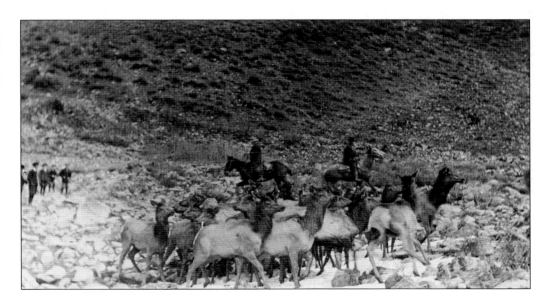

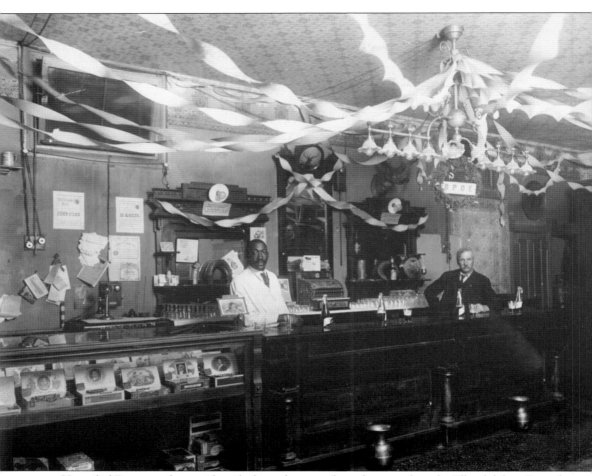

Hannibal Brown and an unidentified member pose for a photograph at the Elks club bar. Over the many years Brown lived in Aspen, he held many jobs and was well known and liked by just about everyone. He was a freelance bartender, custodian, and bootlegger, and ran a little prostitution ring, referring to the young ladies in his employ as his cousins. He also owned a Hudson automobile and would drive the elderly women around town or to Glenwood Springs on shopping excursions. He loved bicycle racing and participated in a number of the races from Aspen to Glenwood Springs. Hannibal Brown died in Denver on October 18, 1950, after suffering from a stroke two months earlier. He moved to Aspen from Topeka, Kansas, around 1890.

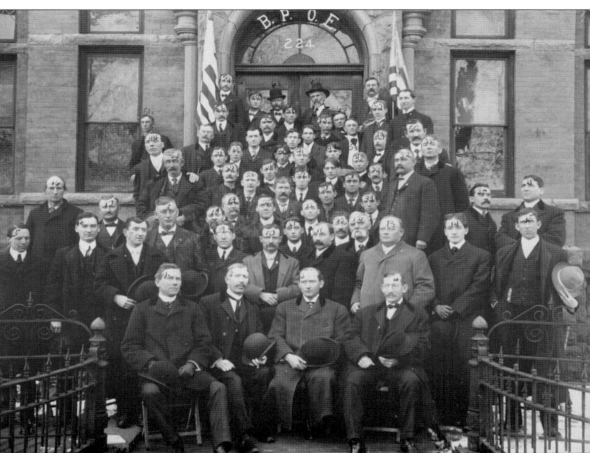

Pictured here sometime between 1900 and 1905, Elks members pose in front of the court house. They are, from left to right, Harold Clark (1), Bob Ryan (2), W.H. McNichols (3), Frank Yates (4), unidentified (5), Phil Kerwin (6), Ike Waters (7), unidentified (8), Joe Selner (9), Blake Moore (10), Ike Rosen (11), Charles Garland (12), Henry Beck (13), Thomas Flynn (14), Ray Par (15) Ed Nevitt (16), Ed Bonnell (17), unidentified (18), Andine (19), Billy Fautz (20), Frank Shields (21), Harry Brown (22), Jim Hetherly (23), True Smith (24), Jim McSkimming (25), Preston Swan (26), unidentified (27), unidentified (28), Joe Hicks (29), Tom Pitts (30), Kasel (31), unidentified (32), LAW Brown (33), unidentified (34), unidentified (35), George Folsom 36), Jeff Hetherly (37) Charles or Peter Hanson (38), Louis T. Teuscher (39), Ernie Cree (40), unidentified (41), John Blewett (42), Bert Brown (43), Tony Rowland (44), unidentified (45–48), Captain Daily (49), Jim Bigley (50), unidentified (51), unidentified (52), Sim McNeil (53), Fred Hart (54), John Larson (55), Andy Hedman (56), Clyde Stevens (57), unidentified (58), Charles Wagner (59),Walter Caine (60), unidentified (61), Thomas Rucker (62), Frank Bruin (63), and Art Hull (63).

Membership in many of the lodges and societies tended to be based on social standing in the community and on ethnic background. In 1899, there were no fewer than 100 different organizations or lodges. Among them were the United Workmen, Elks, International Order of Odd Fellows, Sons of Herman, Knights of Pythias, Masons, Kings Daughter's, Ancient Order of Pyramids, Grand Army of the Republic, Improved Order of Red Men, Orangemen, Chosen Friend's, Knights of Labor, Knights of Honor, and the American Protective Association, to name a few. Pictured above are six Elks, including Charles Wagner, Charles Dailey, Tom Flynn, and Judge Thomas Rucker.

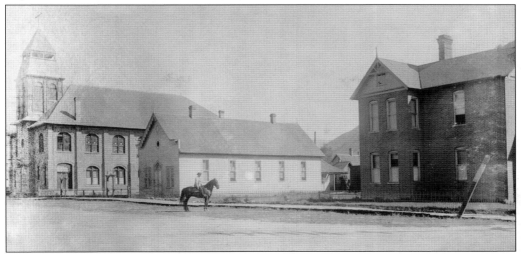

In 1899, Aspen boasted more than 20 churches, including the more mainstream denominations such as Presbyterian, Methodist, Catholic, Lutheran, Seventh-day Adventists, Christian, Protestant, African Methodist, and Church of Christ Scientist. Others were less mainstream and operated out of other church facilities or in town halls. Pictured here around 1900 are the buildings belonging to St. Mary's Catholic Church, including a convent and rectory.

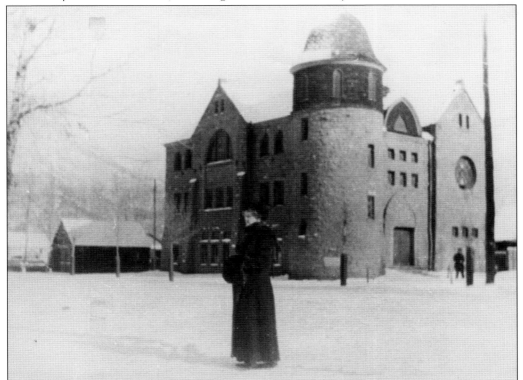

A woman pauses in front of the Aspen Community Church, originally built as a Presbyterian church. Over the years, the church was home to Methodists as well as other Christian sects. This photograph was taken on New Year's Day, but the year is unknown.

Pictured here is the Methodist church and old parsonage located on the southeast corner of Aspen Street and Hopkins Avenue. As membership dwindled and the town's fortunes were lost, the buildings were leveled rather than allowing them to become dilapidated and dangerous.

Pictured here around 1910, the Swedish Lutheran Church was located on Main Street between Second and Third Streets. Rev. A.S.S. Linholn was the pastor at the time. This church fell victim to dwindling membership and funds, and was eventually torn down.

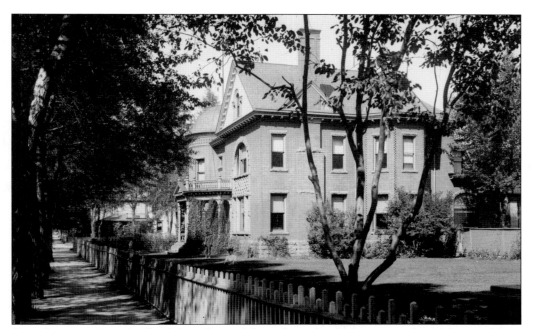

Over the years, Aspen's schools were located throughout the community and served a population that at one time exceed 15,000 residents. Pictured here around 1900 is the Aspen High School, when it was located in the former DRC Brown home at the intersection of North Center Street and East Hallam Street.

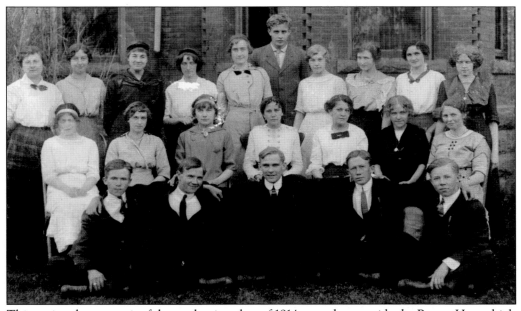

This senior-class portrait of the graduating class of 1914 was taken outside the Brown House high school. In no particular order are Margaret Carroll, Catherine Clark, Charles Dailey, Ethel Epperson, Mildred Feist, Dare Gallagher, Charles Grover, Ellen Holm, Woodward Ingham, Dorothy Koch, Elsie Linder, Mary Marolt, Edith Roman, Louise Putzell, Hazel Shields, Vera Strawbridge, William Shaw, Harold Schwarzel, Geroge Thomson, Olive Veal, Esther Wheeler, and Cecil White.

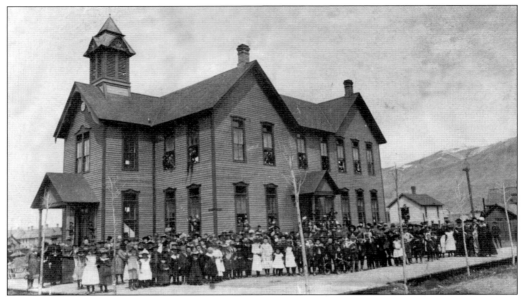

Pictured here is a large group of students and teachers standing in front of the Lincoln School, with more leaning out of the windows of the building. In 1896, enrollment at each of Aspen's four schools was thriving—Aspen High School (43), Lincoln School (453), Washington School (311), and Garfield School (312), for a total enrollment of 1,119 students.

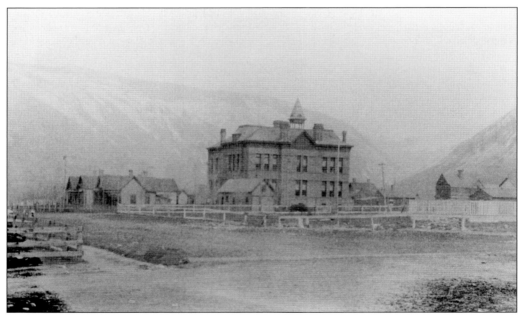

Pictured here is the Washington School, on West Bleeker Street, between Fourth and Fifth Streets. Smuggler Mountain is visible in the background. After a yearlong struggle, locals convinced the school district that the school was in need of replacement. The following year, it was torn down to make room for the new school. The bricks were sold off to be used in the construction of Glenwood Springs Catholic Church.

# Seven

# THE MINES, MINERS, MILLS, AND RAILROADS

Within a few short years of Aspen's discovery, there were hundreds of mines and thousands of claims in the Roaring Fork Valley. Some of these mines never produced any tangible results, while others went on to put Aspen on the map. The silver ore running through the hills brought in prospectors and claim jumpers, all seeking their fortunes.

Aspen's biggest mines were owned by Aspen's richest businessmen, who had a penchant for litigation and enough money to make it worth their while. Often, partners in one mine would be bitter adversaries on the management of other mines.

From 1887 to 1892, eight mines dominated Aspen's mining industry. Of those, seven were in some way connected by their investors. They were the Aspen Consolidated (Durant, Emma, and Aspen), the Compromise, the Smuggler, the Argentum-Juanita, the Park Regent, the Consolidated Aspen Mining and Milling Company, and the Mollie Gibson. The most significant mining lawsuit of its time was the apex suit, which involved the Little Giant Mine and the Durant Mine.

Claim jumping took all forms back then—from actually jumping someone's claims to the more obscure forms involving contentious ownership of a particular vein of ore. Mining laws at the time were vague and often contradicted one another, and owners took advantage of that fact. When the richest of investors came to town, the local lawyers saw blood in the water and went after them with every means available. There were the small-time miners looking to score big, and if the silver did not pan out, then the court system often did.

While legal battles ensued, Aspen continued to need more services. Lixiviation plants were built, as were crushers and milling operations. Aspen needed a way to process its ore and get it to market. Jack trains did a decent job for small loads, but the ore began to pile up waiting for a solution. In 1887, the railroads headed to Aspen in a hotly contested race. On November 2, 1887, the Rio Grande Railroad opened for business after officially arriving on October 27.

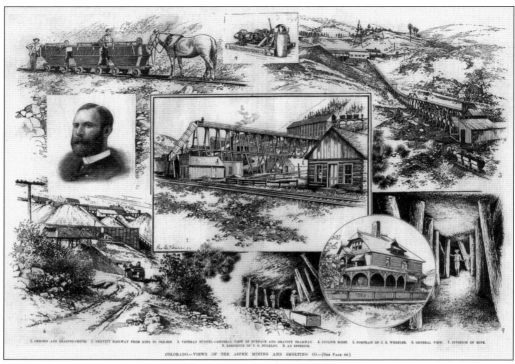

Frank Leslie's Illustrated Newspaper featured a map with insets titled "Colorado—Views of the Aspen Mining and Smelting Co." in the February 22, 1890, issue. Seen here are illustrations of the interior and exterior of a mine, the Veteran Tunnel, a portrait of J.B. Wheeler, and the residence of F.G. Bulkley.

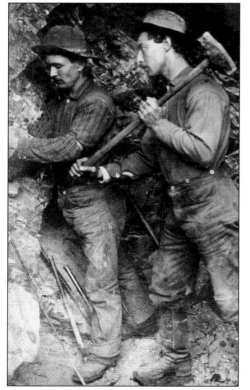

Pictured here are two miners using hand drills; one miner holds the drill head while the other hammers. The photograph was taken in November 1891 in the Della S. Mine on Smuggler Mountain.

Two men are going down in an ore bucket in the Aspen Mine, often the only way to get the miners down into the shafts. Mines of the day tended to either have shafts with hoists (as depicted here) to bring up the ore or horizontal tunnels in which the ore could be brought out by small ore cars.

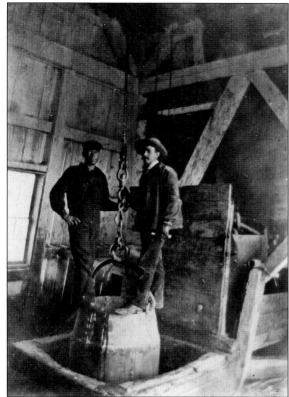

Pictured here is some construction at the Holden Lixiviation works on the western edge of Aspen across Castle Creek. In the background are the main buildings, with the stacks to the far left. In the foreground are several areas under construction. Red Butte can be seen in the background to the right.

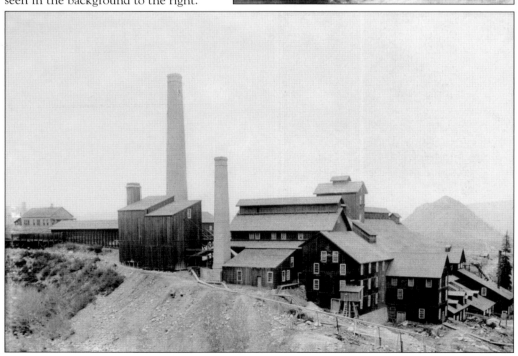

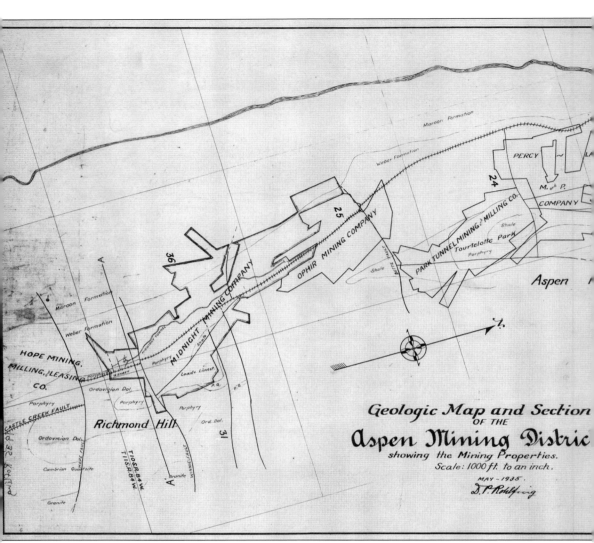

This geological map features sections of the entire Aspen Mining District. The map includes fault-line information and the location of mining companies. Richmond Hill is located up toward Ashcroft behind the ridgeline southeast of Aspen Mountain. The Midnight Mining district is directly behind the top of Aspen Mountain where the Ophir and Park Tunnel Mines were

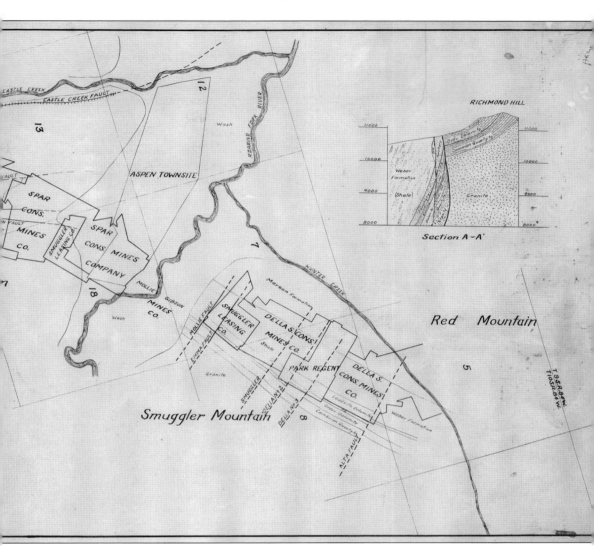

on the backside of Shadow Mountain. All the mines in the middle of the map were on Aspen Mountain down and into Aspen. Smuggler Mountain is across the valley from Aspen Mountain on the north side of town.

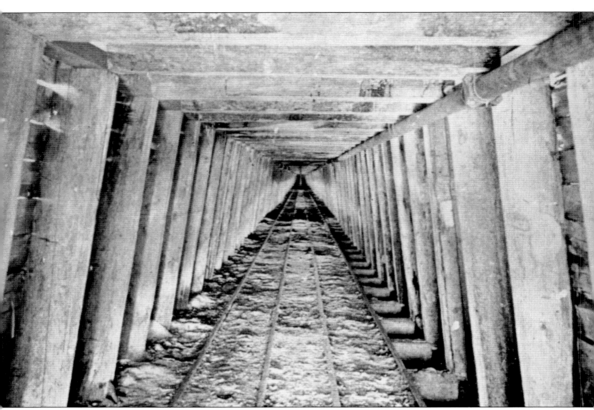

Pictured here around 1893, the Cowenhoven Mining Transportation and Drainage Tunnel Company was formed to dig this much-needed support tunnel for all of the mines in the Smuggler Mining district. DRC Brown and H.P. Cowenhoven subscribed as major investors along with Jerome Wheeler and Elmer Butler, who held interest in several of the mines. D.W. Brunton was hired as chief engineer, ground was broken in 1889, and work continued for three years. The work was dangerous and unpleasant, as water was encountered the whole distance, usually 650 to 1,000 gallons per minute flowing out of the tunnel. Before connecting to the other mines to create air circulation, air had to be continuously pumped into the tunnel, or miners would perish. As the tunnel passed under a mine, connections were made from above for hauling ore, making the tunnel profitable from the very beginning. As designed, it passed 500 to 1,000 feet below the lowest levels of the mines it crossed. The tunnel proved to be a great success.

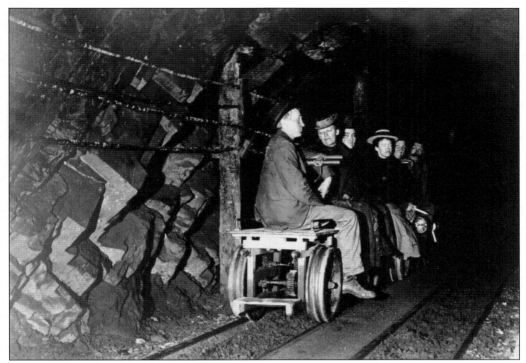

Pictured here is a group of six unidentified people sitting on a hand-propelled tram car in the Cowenhoven Tunnel in Smuggler Mountain. Tours into the mines were common, and many dressed up for the occasion.

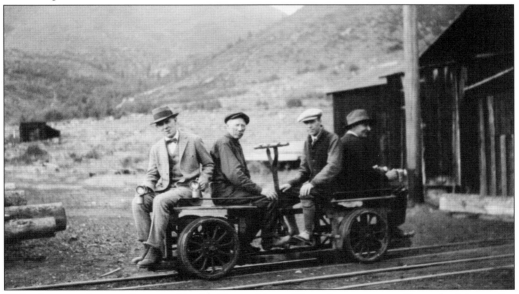

This photograph was taken outside the Cowenhoven Tunnel entrance on Smuggler Mountain. A group of four men is sitting on a tram car on the tracks heading inside the tunnel. These small tram cars were propelled by the riders by pushing back and forth on the handle between the center passengers. The trams took a lot of effort to get started.

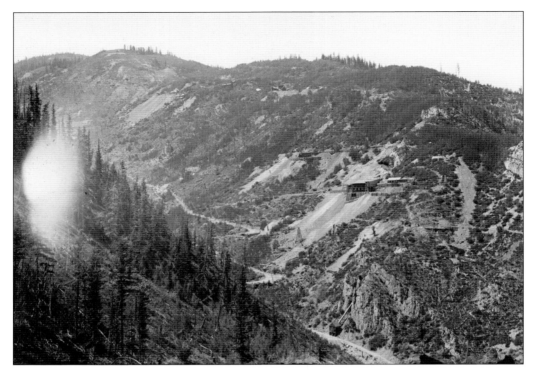

One of the most profitable and controversial mining districts in Aspen was in Spar Gulch and on the ridge above the gulch. This was the center of some of the most heated legal battles and land grabs in Aspen's history. Pictured here around 1890 are the Spar (1), Vallejo (2), Emma (3), Aspen (4), Conemara (5), and the Jefferson Davis (6) Mines. The mines are numbered from one to six, and they are in the area of what is now the Silver Queen ski run. These are early images due to the lack of infrastructure around some of the mines.

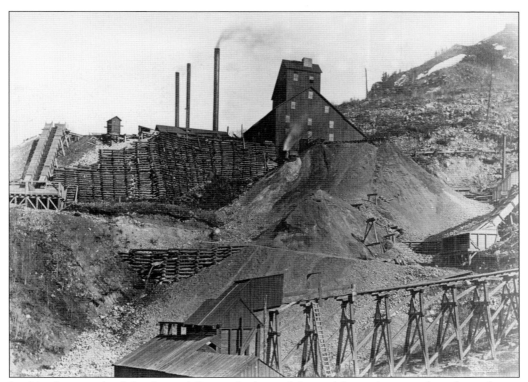

In this photograph of the Aspen Mine at the base of Aspen Mountain, several smokestacks are visible. There are large timber retaining walls near the buildings as well as mine dumps. The Veteran Tunnel was part of the Aspen Mine complex.

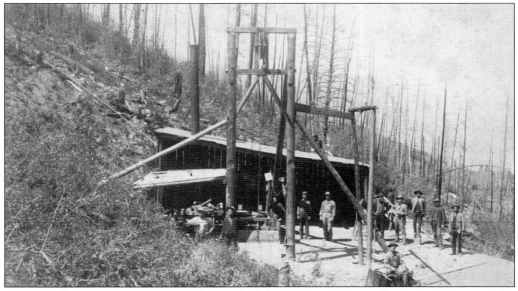

A group of men stand around a building at the Mineral Farm Mine at Smuggler Mountain. The image is from Dr. Justin Bourquin of Youngsville, Pennsylvania, whose family owned mining claims in the Aspen area. This site might also be connected to the Mineral Farm.

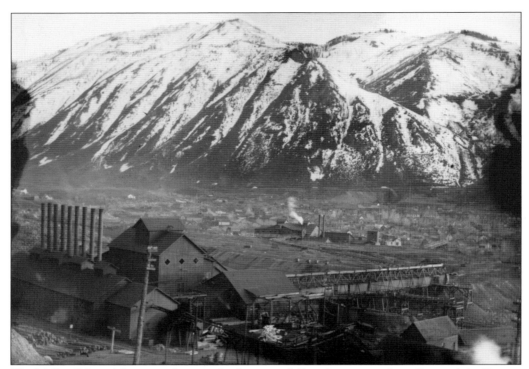

The Mollie Gibson Mine complex is in the foreground, East Aspen is in the valley, and the Durant Mine is across the valley at the foot of Aspen Mountain. The cut in the hill above the Durant facilitates the Midland loading ore from some of the mines higher up on Little Nell.

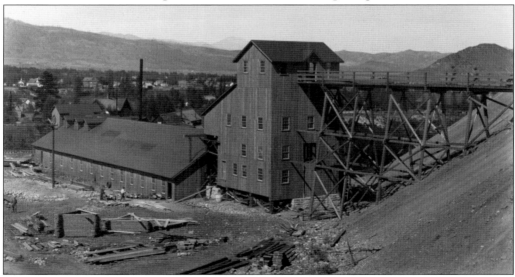

Pictured here are the lower buildings of the Mollie Gibson Mine on Smuggler Mountain, where the ore was loaded into railroad cars for shipment. The photograph was taken facing west with Aspen in the background, and the surrounding hills are barren of trees; however, the cottonwood trees lining the city streets have grown to a height where many of the structures can no longer be seen.

This photograph of the Smuggler compressor is unlike many compressor shots in that this one is outdoors. The compressor was used to power the water pumps in the mine and provide much-needed fresh air. Part of Aspen and Shadow Mountain can be seen in the background.

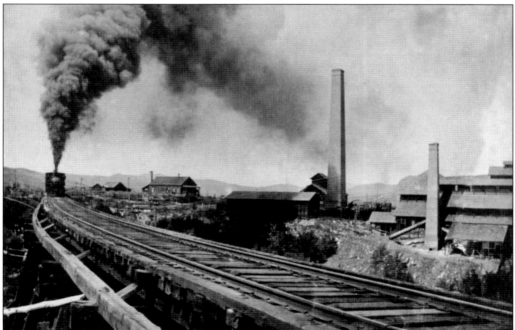

An inbound Colorado Midland Railroad train runs in front of the Holden Lixiviation works.

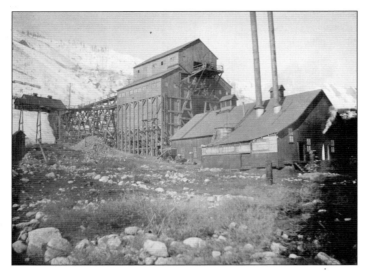

Pictured here on March 22, 1901, is the Durant Tunnel ore house at the base of Aspen Mountain. The Durant Mine played a very prominent role in Aspen's mining days; located near the foot of Aspen Mountain, it was visible from anywhere in the valley. It had numerous buildings and structures going up the side of Aspen Mountain. The mine employed hundreds of workers, horses, mules, and donkeys.

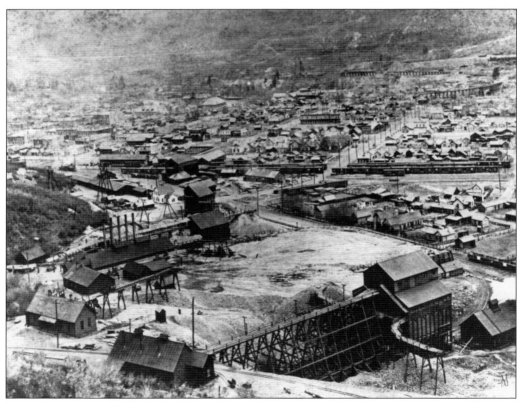

In this photograph looking over Aspen from Aspen Mountain, the mine structures at the base are visible, and Hunter Creek can be seen at upper right. The Argentum-Juniata Mine is on the left, and the lower Durant Mine is on the right. The east end of Aspen and the Colorado Midland railroad yards are also visible in this image from about 1915.

At the Durant Mine Tunnel ore house, ore cars pulled by mules are lined up on tracks leading into the building, and the town of Aspen can be seen in the background.

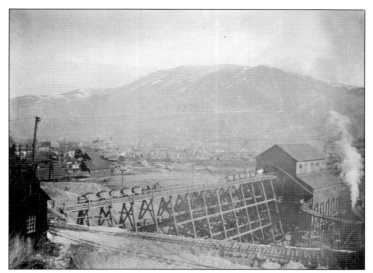

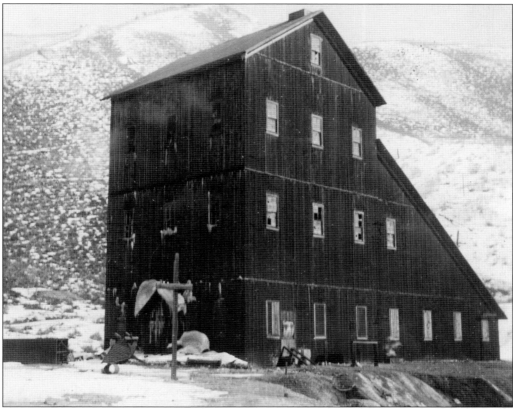

Pictured here around 1900, the Free Silver Mining Company shaft house, which became part of the Mollie Gibson and Smuggler mining complex, facilitated access into the lower shafts. According to Aspen historian Larry Fredrick's research, it was the Free Silver Shaft that was used by the deep-sea divers in 1911. Equipment at the Free Silver included what was at the time the largest-capacity electric hoist in the world.

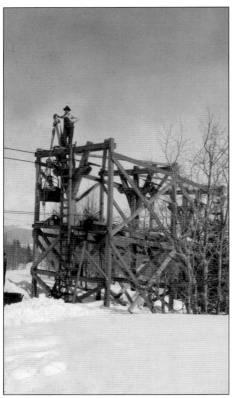

Pictured here is a man standing above the Park Tunnel Tramway base station, which was located on the back side of Aspen Mountain overlooking Castle Creek. The easiest way to get the ore from the mine was to bring it down using a tramway. The owners decided to bring the ore down into Aspen by what was expected to be a rail yard or convenient loading facility. These structures were known as tipples.

Pictured here around 1920 is the main building of the Park Tunnel Tramway, the Veteran Tunnel, and Durant Avenue below. The Colorado Midland, later used by the Rio Grande, crosses in front of the Park Tunnel Tramway tipple. What is known as the Little Nell is on the left side.

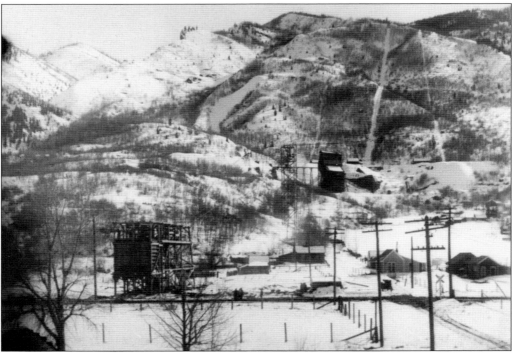

Tommie McQuiag, a blacksmith, stands in front of a corrugated tin building at the Smuggler Mine.

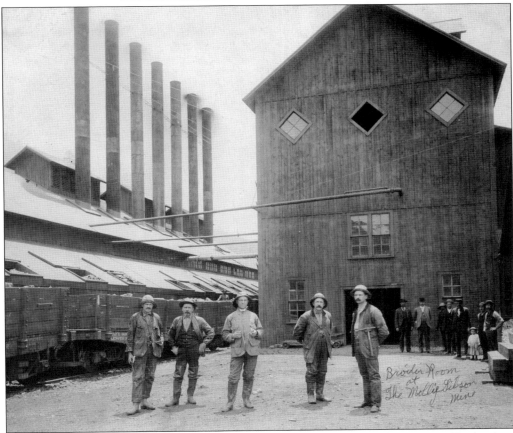

Pictured here are the boiler rooms and loading facility of the Mollie Gibson Mine. Hauls of ore are loaded into cars and prepared to ship via rail.

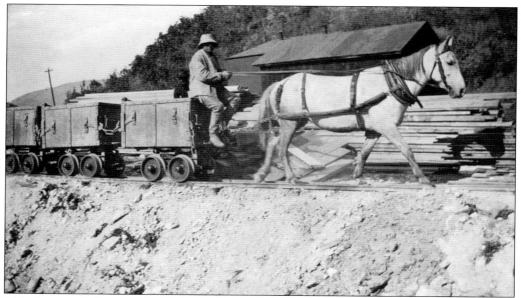

This photograph features a horse-drawn ore train at the Cowenhoven Tunnel. Many of the animals that worked at the mines spent their entire working existence at the same mine, and some never saw the light of day, spending all of their time working and living underground. There were even underground paddocks for them to rest and eat in.

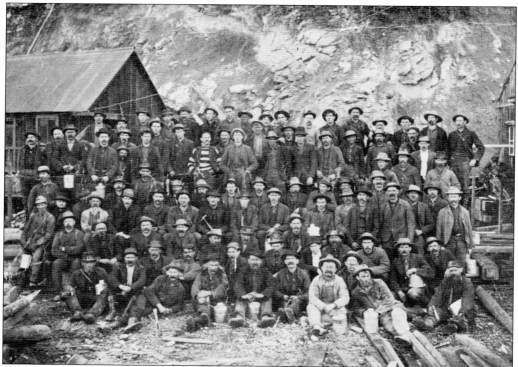

This large group of miners pictured outside the Durant Mine around 1904 is captioned, "One Shift of Men on the Great Durant Mine at Aspen."

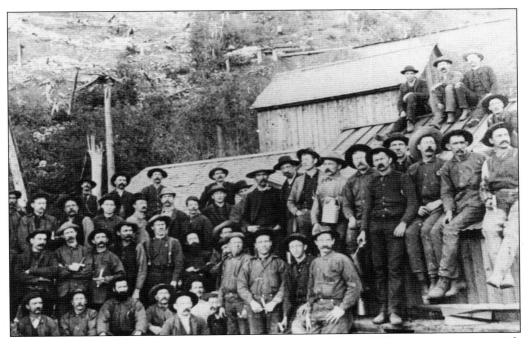

Miners sit for a portrait outside the Franklin Mine, on top of the roof. The men are in rows, with some standing and others sitting or leaning. Three men are sitting on top of the peak of the roof to the far right.

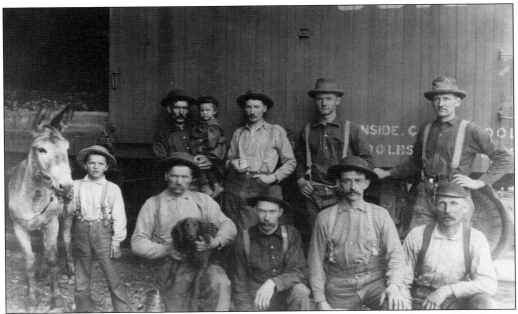

This group of unidentified men is standing in front of a freight car at the ore house of the Durant Mine. These types of photographs were rarely documented and often had interesting or odd items in them such as the boy to the far left holding the reins of a donkey, a man and his dog, and a man holding a small child.

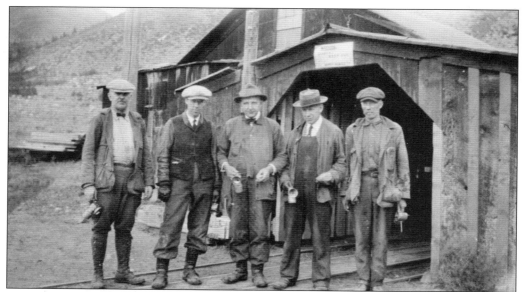

Around 1920, Five men holding lamps stand in front of the entrance to the Cowenhoven Tunnel. The sign above their heads reads, "Warning, Danger, Keep out, Aspen Mines Co." James Hetherly is at far right.

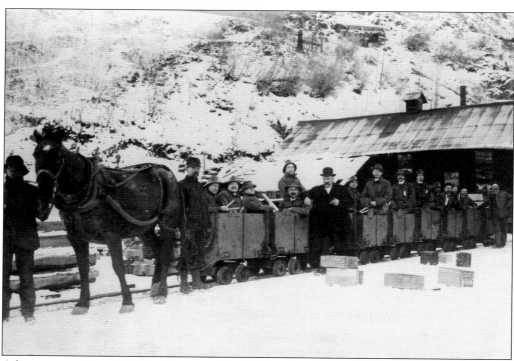

A large group of men is sitting in ore cars hitched to a horse outside the Hope Tunnel up Castle Creek. On the ground are numerous wood crates stamped with "Granite Candles" on the ends. Many of the passengers are holding candles as well.

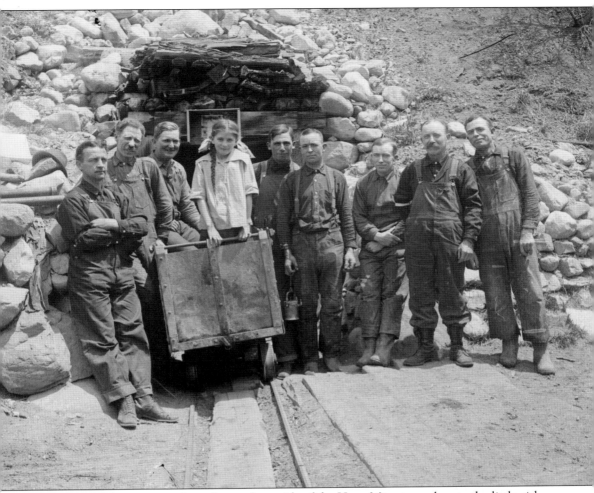

Around 1914, a large group of people stands outside of the Hope Mine tunnel; note the little girl with braids and a white dress standing inside an ore car at center. She is Florence Parr (1906–1973), younger daughter of Lillian (Salholm) Parr, who was employed there from 1913 to 1916 and the author's great-aunt. Her father, Marvin L. Parr, died in 1913 in Rifle, Colorado, and Lillian returned to Aspen and supported her two daughters at the Hope Mine and later in Rochester, Nevada, before moving to southern California in 1917. Her father was Charles Eric Salholm, a mining engineer who lived with his wife, Emma, at the head of South Mill Street. Evelyn Parr (1898–1987) attended Aspen High from 1913 to 1915 while living with her aunt Hattie Parr on West Hallam Street.

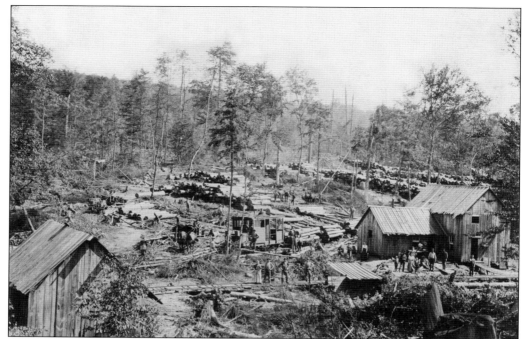

The McDonald Sawmill is pictured here around 1895, with logs scattered everywhere. There is a small group of people toward the middle, another group standing in front of a building to the right, and another group of people standing on a trestle track in the center foreground. The mill was so big that it had a small railroad (center) on the property to move the logs and lumber around.

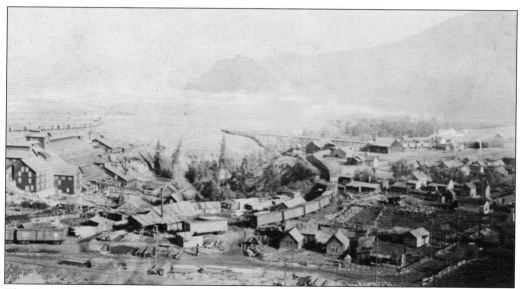

The City Sawmill, across Castle Creek from the Holden Lixiviation Plant, is pictured here on October 10, 1896. The sawmill was located at the western end of Cooper Avenue; one can see the Castle Creek Bridge, and Red Butte is obscured by the damage to the photograph. Just on the edge of the ravine is the Texas Smelter structure, near the bridge.

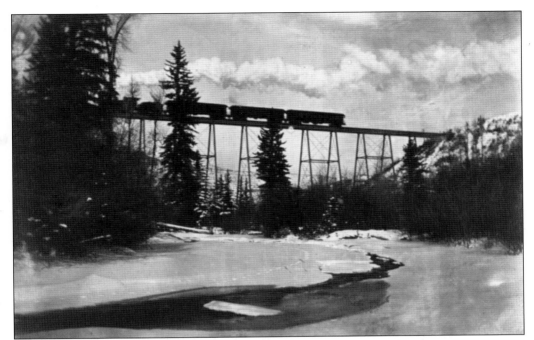

A Colorado Midland train crosses the Maroon Creek Trestle in winter; what is a mining community without railroads to get the ore to market? It took several years for the two railroads to get to Aspen. The railroads each came into the valley on opposite sides and only crossed paths at one intersection on the east side of town, which almost resulted in bloodshed over the rights.

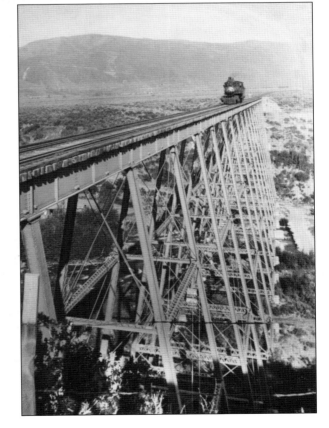

Pictured here is an inbound Colorado Midland train crossing the Maroon Creek Trestle in summer. Both of the Colorado Midland trestles were steel structures, a relatively new building material for that purpose, while other Colorado railroads were still building wooden trestles.

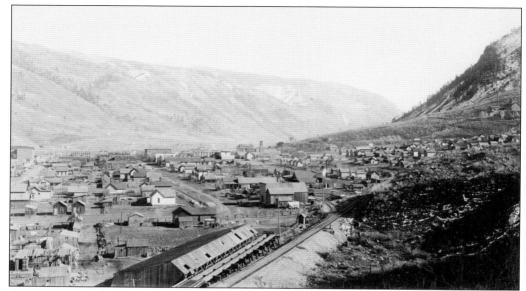

Aspen is captured here from a vantage point on Shadow Mountain in 1891 or 1892. The Colorado Midland tracks are in the foreground, and the Koch Lumber Company is visible. Little Nell is on the right with the fire tower just below. Some of the older homes in the photograph are made of rough-cut lumber.

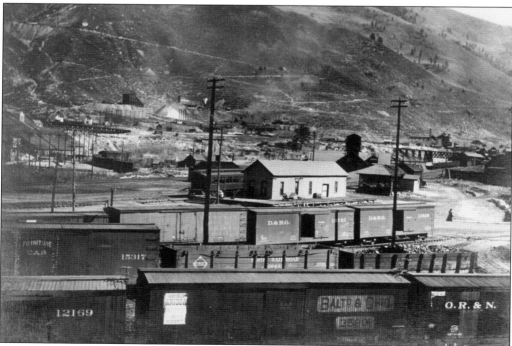

Pictured here around 1902 is the Denver & Rio Grande Railroad yard. There are three trains in the foreground: a Baltimore & Ohio, an Erie Railroad, and a D&RG. Several mines are visible in the background on Smuggler Mountain, including the Mollie Gibson, Smuggler, Free Silver, and Johnson, as well as the Smuggler Mill.

*Eight*

# LIFE IN A SMALL TOWN AT THE END OF A BOOM

The repeal of the Sherman Silver Purchase Act in 1893 was the final nail in the coffin for Aspen's silver industry and the businesses that either supported it or benefitted from it. That death sentence pretty much included everything but ranching and farming for the people of the Roaring Fork Valley and Aspen.

Aspen, once boasting a thriving population, was now facing city blocks of vacant or dilapidated homes and businesses. Many people barely made it out of town with the clothes on their backs. The wealthy fared no better in most cases. Some of Aspen's biggest names retired to obscurity, eventually passing on with little or no money or friends. The wealthy who did get out west, south, or east to try their hands at success one more time. David M. Hyman and John J. Hagerman made it out in one piece, a smaller piece to say the least, and went on to other ventures. Hyman even came back one last time to try to reopen his mines, but in the end he failed to achieve any real success. Hagerman moved to the Southwest and experienced moderate success in railroads, ranching, and land development.

Families that stayed in the valley learned to live off the land, and not under it. Times were tough, yet they all prevailed and actually thrived.

Many of the secret societies, union halls, and even churches failed. The Aspen Elks lodge and a few of the churches stood the test of time. The Colorado Midland Railroad failed, but the Denver & Rio Grande continued to serve the community for decades after the mills and mines closed.

Aspen was down but not out. Much of the remaining people and abandoned metals contributed to the war efforts of World Wars I and II. Some men came home, and others did not. By World War II, Aspen's future was beginning to take shape—skiing was catching on.

Once a thriving community with every square block built up, the end came quickly. City blocks of buildings were abandoned and torn down for use elsewhere or burned to heat the homes of remaining residents. These two photographs show how in just a few years (1923–1930) many of the downtown buildings had been removed, leaving vacant lots.

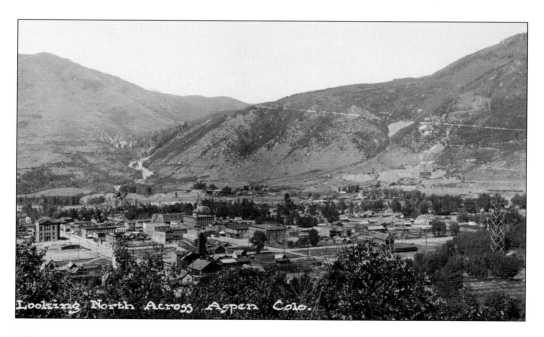

Looking North Across Aspen Colo.

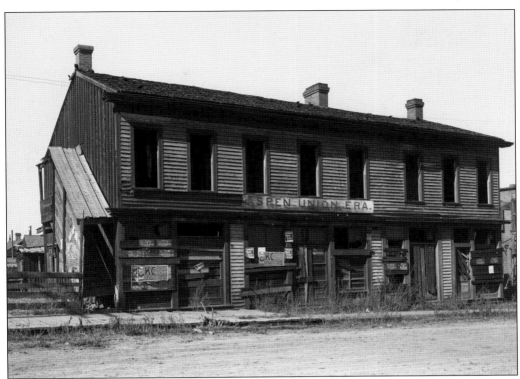

Pictured here, the *Aspen Union Era* newspaper building is boarded up. The paper was once owned by former governor Davis Waite and lauded itself as the voice of the miners' union. At one time, Aspen had nearly a half-dozen newspapers, but the quiet years saw the survival of only one daily paper, which eventually dropped to one printing per week. The *Aspen Times* became the sole voice for the people of the valley.

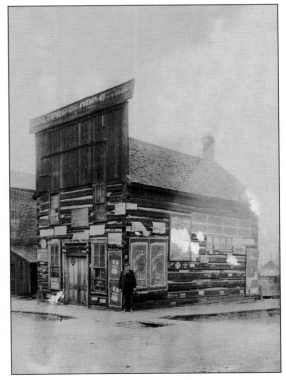

One of Aspen's earliest commercial buildings, this structure was built of logs and sported a false front. This faded photograph is of the first grocery store in Aspen, the Western Slope Store, across from Armory Hall on Hopkins Avenue near the corner of Galena.

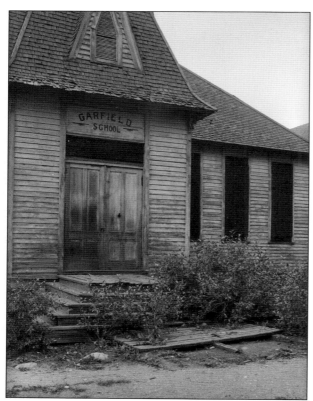

In 1906, as Aspen's population dwindled, the school board looked for ways to cut its costs. One option they chose to exercise was to close the Garfield School and move what few students attended that school to the Lincoln School. This move reduced the school district's budget by a quarter. These photographs from about 1910 show how quickly the Garfield School fell into decline. It was eventually torn down.

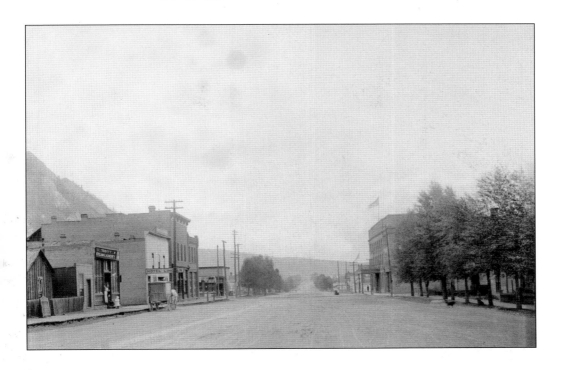

Pictured here around 1920 is Main Street and the Hotel Jerome with the *Aspen Times* building in the foreground. Also visible are the Catholic church and the Chitwood building. By the 1920s, life in Aspen had become very quiet in the summers and downright dead in the winters. Some of the returning soldiers from World War II came home to a nearly deserted town.

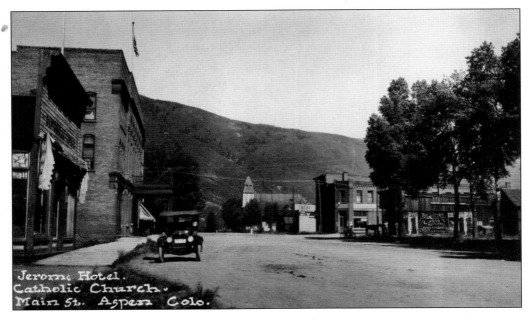

Jerome Hotel.
Catholic Church.
Main St. Aspen Colo.

Some winters were more severe than others, and in the mid-1920s, the Roaring Fork valley experienced a winter with very little snow. It was a rare occurrence to have so much cold and so little snow, but Henry Beck (right) and one of the Chisholm brothers took advantage of the opportunity to go skating on Snowmass Lake. (Courtesy of the Beck family archives.)

Around 1926, Henry Augustus Beck and his mother, Elizabeth Rockefeller Beck, pose in front of the home that Henry's father, John Alton Beck, built in the late 1880s. In a short period of Aspen's history, Henry and others like him were already third-generation Aspenites. (Courtesy of the Beck family archives.)

# BIBLIOGRAPHY

Hyman, David Marks. *The Romance of a Mining Venture*. Cincinnati, OH: Larchmont Press, 1981.

Rohrbough, Malcolm J. *Aspen, The History of a Silver Mining Town 1879–1893*. Boulder, CO: University Press of Colorado, 2000.

Shoemaker, Len. *Pioneers of the Roaring Fork*. Denver, CO: Sage Books, 1965.

Wentworth, Frank L. *Aspen on the Roaring Fork*, Special Edition. Silverton, CO: Sundance Publications Ltd. for the Aspen Historical Society, 1976.